Cristina Portolano

# FRANCIS BACON

## The Story of his Life

© Prestel Verlag, Munich · London · New York, 2022
A member of Penguin Random House Verlagsgruppe GmbH
Neumarkter Straße 28 · 81673 Munich

Original title: *Francis Bacon. La violenza di una rosa*
© Centauria srl 2019
© texts and illustrations Cristina Portolano 2019

Editorial direction: Claudia Stäuble, Josephine Fehrenz
Translation from Italian: Katharine Cofer
Copyediting and typesetting: VerlagsService Dietmar Schmitz GmbH
Proofreading: Jonathan Fox
Design and layout: Studio RAM
Production management: Andrea Cobré, Luisa Klose
Separations: Schnieber Graphik, Munich
Printing and binding: Alföldi, Hungary
Paper: Profimatt 150g/m$^2$

Verlagsgruppe Random House FSC® N001967

Printed in Hungary

ISBN 978-3-7913-8842-7

www.prestel.com

Cristina Portolano

# FRANCIS BACON

The Story of his Life

PRESTEL

MUNICH · LONDON · NEW YORK

# PREFACE

by Cristina Portolano

" I think it's really difficult to talk about painting. Painting is a world all its own, it's self-contained. When people talk about painting, they don't usually say anything interesting. There's always something superficial. What is there to say about it? In the end, I think one can't talk about painting. One just can't."
(based on *The Brutality of Fact: Interviews with Francis Bacon* by David Sylvester)

The above is an imagined response from Francis Bacon if someone were to have asked him to talk about his work and his perception of painting.

Francis was an artist who always refused any kind of pigeonholing, categorization, or banal interpretation of his work. I can't blame him: every artist needs to feel unique.

In August of 2018 I was on vacation in Dublin, the city where Bacon was born, and I visited the faithful reconstruction of his last studio at Dublin's Hugh Lane Gallery. I succumbed to the fascination of that chaos of papers, paint-encrusted brushes, and piles of paintboxes, and, unconsciously, I felt the desire to have a space just like it.

Coincidentally, some months later I received the offer to write this book. I accepted immediately, drawn by an inexplicable attraction to a person seemingly so far away from me, and yet somehow so close.

The more I immersed myself in the life and work of Francis, the more I noticed other coincidences, similarities that made me feel more and more connected to him.

I was struck, for example, by the project of his series of works *Man in Blue*. In an interview with David Sylvester, Bacon confessed that he was working on a series of pieces about dreams and about hotel rooms, and I too for a time was fascinated with hotel rooms, with their fleeting, mysterious, and erotic atmosphere. I drew them, depicted them, I set stories and comic strips in them. My drawings illustrated and narrated that which Francis, in his work, revealed through painting: the unbridgeable gap between the idea, fruit of a visceral and instinctive intuition, and the interpretation of the finished work, a reduction to words of a concept that was immensely different from language itself, the product of a cultural system that, as such, set up rational rules for itself.

With Francis opposition was not merely relegated to his art. In his personal life too, he was a man of great passions and stark contrasts, capable simultaneously of infinite tenderness toward those he loved, and of sharp cruelty toward those who displeased him. Over the course of his lifetime many people asked him about the motivation for such violent, cruel, and desperate painting. I believe it is the fruit of a primal tenderness and a disenchanted gaze. A sense of fascination with the body and with tangible things that he tried to grasp and understand through painting: similar to what we graphic artists try to do with our stories.

To write this book I intentionally emphasized certain facts and inserted others that are not so easy to confirm. This, however, does not betray the story, on the contrary—sometimes it's necessary to lie to give a sense of the real. To make things truer than truth we need the narrative artifice: a notion Francis would have liked. Generally speaking, to tell the story of Francis Bacon I referred mostly to three books: *Francis Bacon in Conversation with Michel Archimbaud*, Daniel Ferson's *The Gilded Gutter Life Of Francis Bacon*, and David Sylvester's *The Brutality of Fact: Interviews with Francis Bacon*.

The numerous photographs contained in these volumes and found on the Internet also proved to be valuable material for my book. Most of these were taken by John Deakin and Daniel Farson, two photographers who are also quoted and represented in this book.

To maintain a balance between my signature and that of Francis himself, I decided to use, almost as an alchemical formula, the colors he used: the mauve, the red, the acid yellow, and the blue, colors from his chromatic palette that alternate with more tender pastel hues.

Of course, it is not easy to collaborate with an artist who is no longer here but seems as if he were. Along with all the conflicts, contrasts, and reflections, I also started to feel in these months a sort of "joyous despair," the same that I hope to arouse in you, the same that, according to Francis, defined his life.

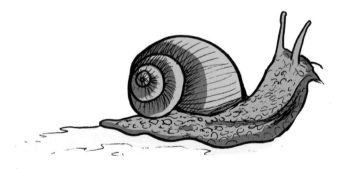

"My painting is often considered horrible because
it is direct. It proves the sleep of reason in those who find it
monstrous, while I show how the awakening of the monsters
has transformed reason. You don't want that other reason.

Why was Hitler able to become, in the face of almost universal
indifference, such a delusional murderer? How is it that Stalin
was such a lauded professional of false witness? You would
*really* know if you weren't all today such self-righteous
round-the-clock addicts of planetary imaging.

Nevertheless, I, the painter, must expose the naked truth
of the theater in progress."

from *Les passions de Francis Bacon* by Philippe Sollers

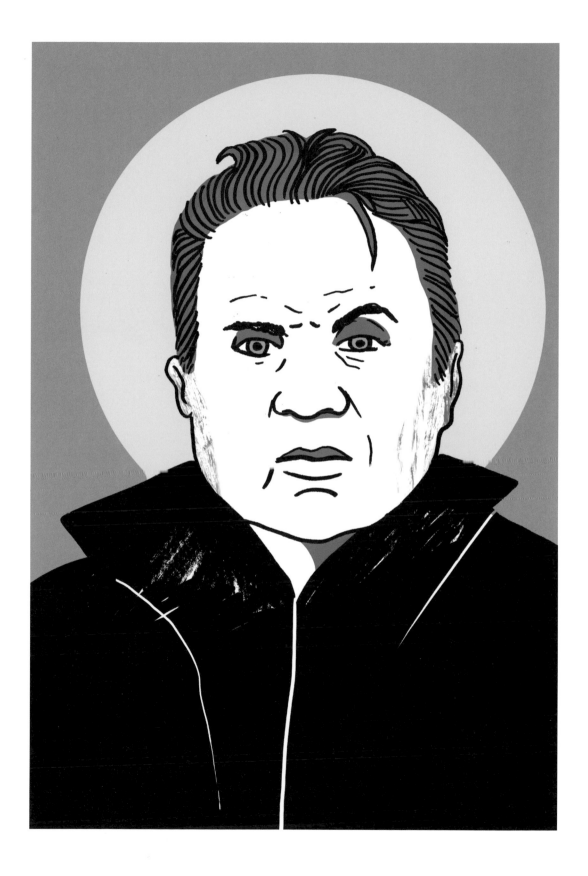

FRANCIS IS BORN IN DUBLIN ON OCTOBER 28, 1909, TO PARENTS OF ENGLISH ORIGIN.

WINNIE
HIS MOTHER

HE HAS TWO BROTHERS, WHO BOTH DIE AT A YOUNG AGE, AND TWO SISTERS. HIS FATHER, EDWARD, AFTER HAVING SERVED IN THE MILITARY, ENLISTS WITH THE WAR OFFICE IN LONDON AS A VOLUNTEER.

THE FAMILY LIVES IN THE CAPITAL FOR THE ENTIRE PERIOD OF THE GREAT WAR.

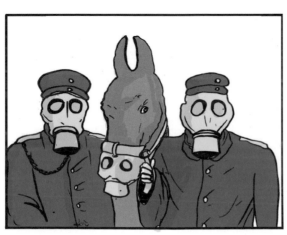

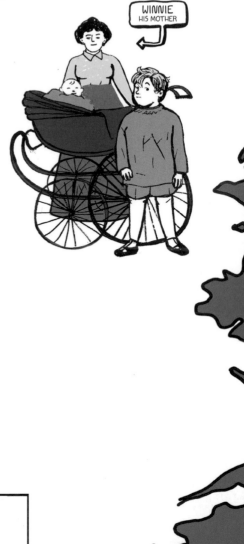

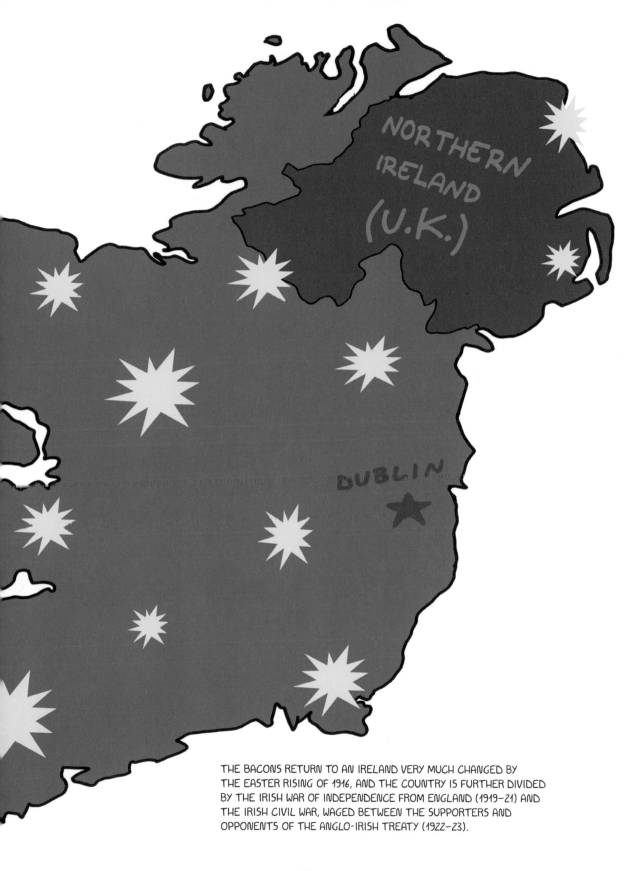

NORTHERN IRELAND (U.K.)

DUBLIN

THE BACONS RETURN TO AN IRELAND VERY MUCH CHANGED BY
THE EASTER RISING OF 1916, AND THE COUNTRY IS FURTHER DIVIDED
BY THE IRISH WAR OF INDEPENDENCE FROM ENGLAND (1919–21) AND
THE IRISH CIVIL WAR, WAGED BETWEEN THE SUPPORTERS AND
OPPONENTS OF THE ANGLO-IRISH TREATY (1922–23).

FROM EARLY CHILDHOOD FRANCIS KNOWS ABOUT DANGER AND FEAR, FROM THREATS BY SINN FÉIN TO WARTIME BOMBS.

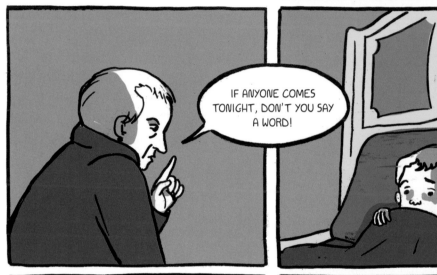

IF ANYONE COMES TONIGHT, DON'T YOU SAY A WORD!

PUM PUM PUM PUM

COF COF

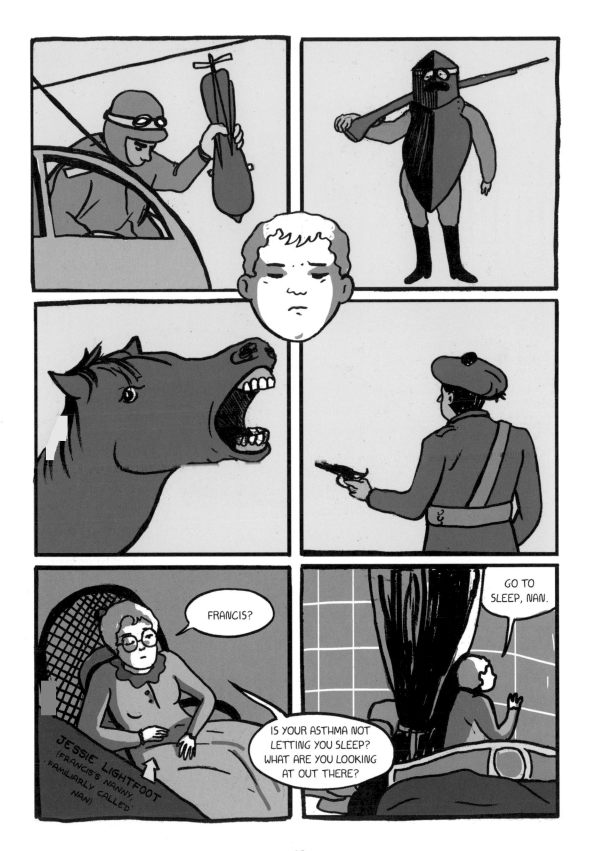

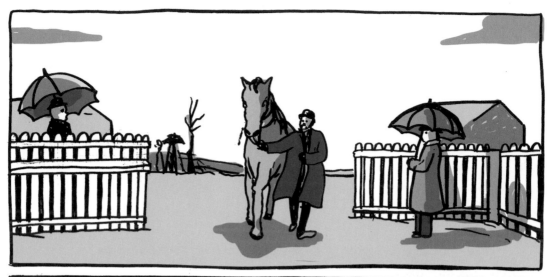

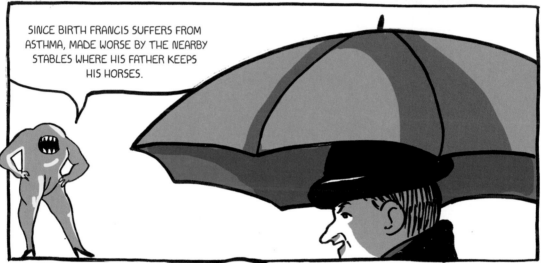

SINCE BIRTH FRANCIS SUFFERS FROM ASTHMA, MADE WORSE BY THE NEARBY STABLES WHERE HIS FATHER KEEPS HIS HORSES.

DID WE LOSE AGAIN, EDDIE?

EH EH

IN ANY CASE, THE BACON FAMILY LIVES IN COMFORTABLE CIRCUMSTANCES, RELOCATING A NUMBER OF TIMES BETWEEN IRELAND AND LONDON.

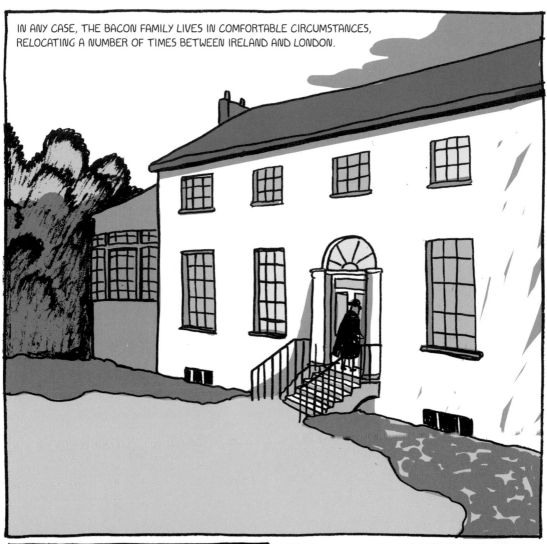

AT THE AGE OF 16, FRANCIS IS FORCED TO LEAVE HIS FAMILY HOME.

HIS ONLY CRIME IS BEING EFFEMINATE.

IN LONDON HE IS ABLE TO SURVIVE THANKS TO THE THREE POUNDS STERLING A WEEK THAT HIS MOTHER, WINNIE, SENDS HIM.

FRANCIS CHANGES JOBS FREQUENTLY AND PREFERS TO STEAL OR MAKE HIMSELF AVAILABLE TO WEALTHY MEN.

18

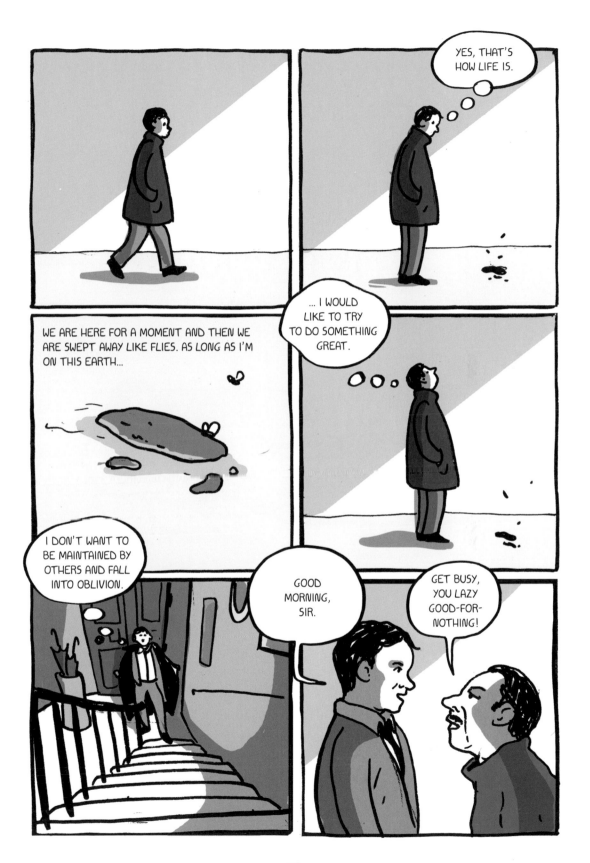

YOUR FATHER SENT ME TO GET YOU. IT'S TIME YOU BECAME A MAN.

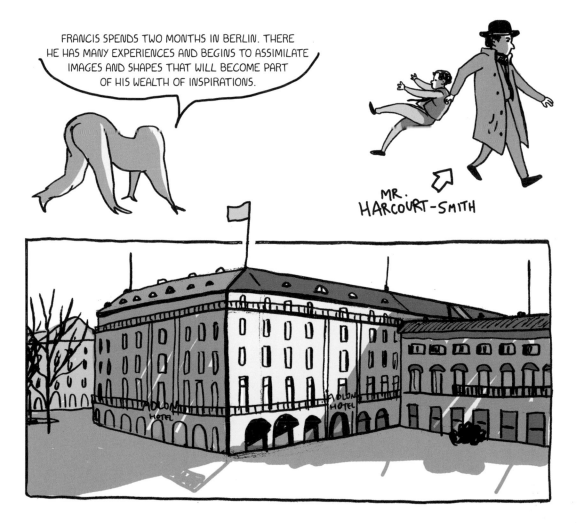

FRANCIS SPENDS TWO MONTHS IN BERLIN. THERE HE HAS MANY EXPERIENCES AND BEGINS TO ASSIMILATE IMAGES AND SHAPES THAT WILL BECOME PART OF HIS WEALTH OF INSPIRATIONS.

MR. HARCOURT-SMITH

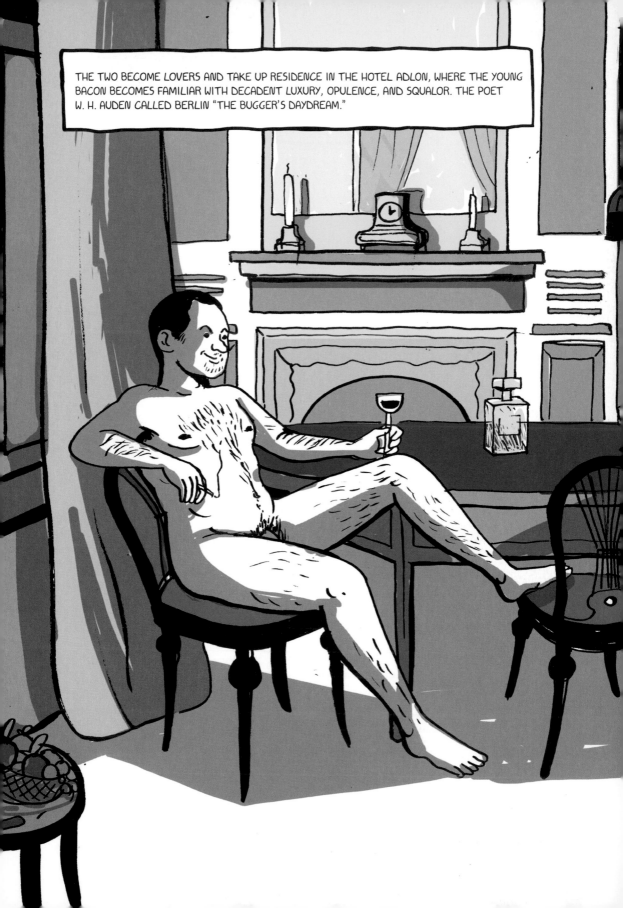

THE TWO BECOME LOVERS AND TAKE UP RESIDENCE IN THE HOTEL ADLON, WHERE THE YOUNG BACON BECOMES FAMILIAR WITH DECADENT LUXURY, OPULENCE, AND SQUALOR. THE POET W. H. AUDEN CALLED BERLIN "THE BUGGER'S DAYDREAM."

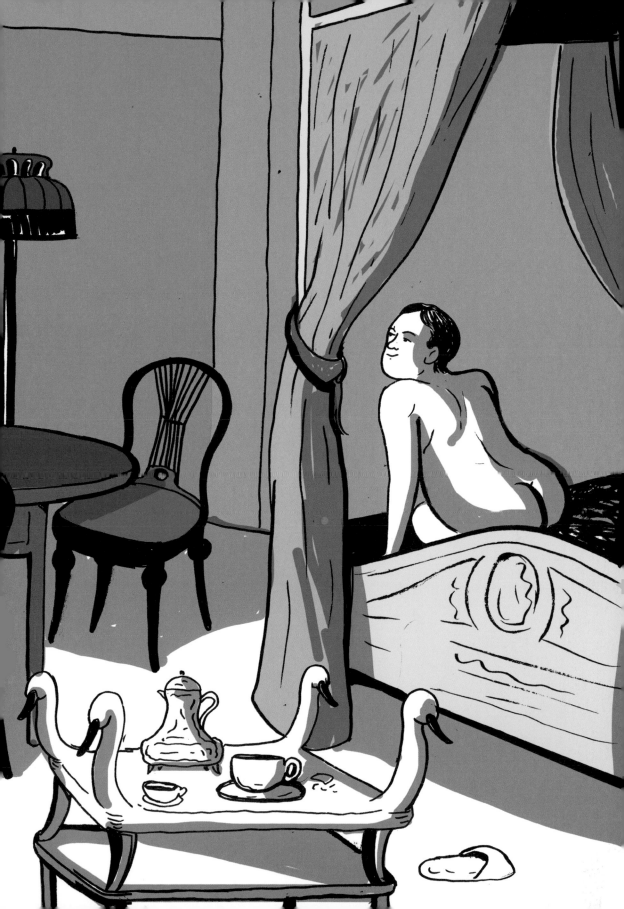

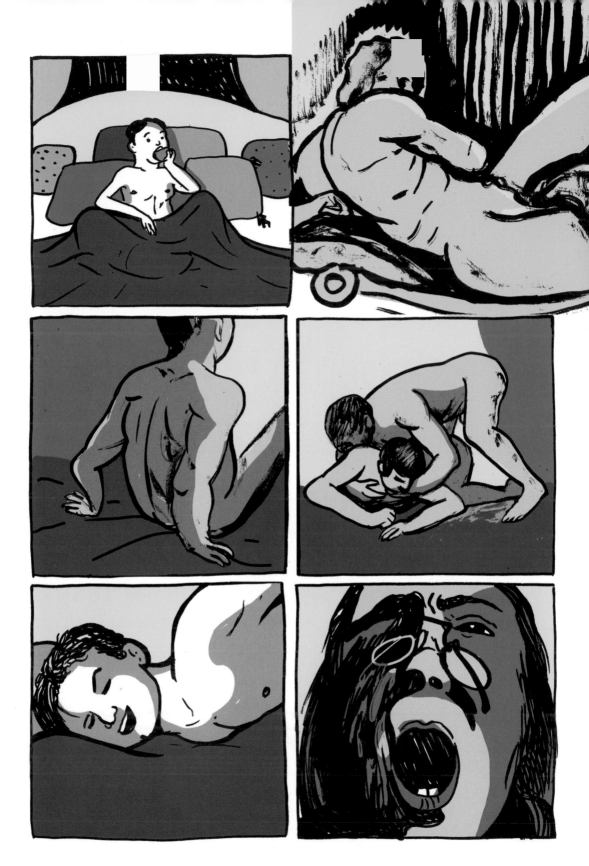

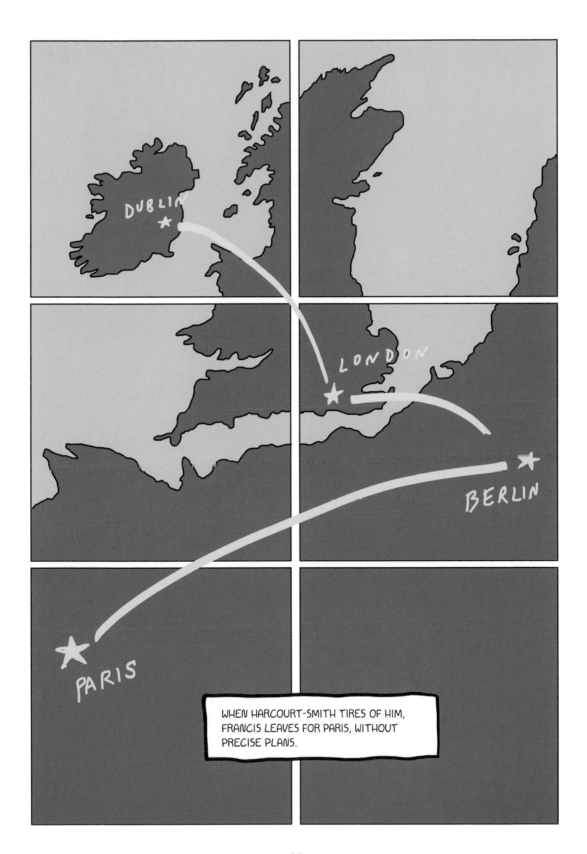

WHEN HARCOURT-SMITH TIRES OF HIM,
FRANCIS LEAVES FOR PARIS, WITHOUT
PRECISE PLANS.

MADAME BOCQUENTIN, WHOM HE MEETS BY CHANCE IN AN ART GALLERY, DECIDES TO TAKE HIM UNDER HER WING, HOSTING HIM AT HER HOUSE, NEAR CHANTILLY. SHE TEACHES HIM FRENCH AND INTRODUCES HIM TO THE HIGHER SOCIAL SPHERES.

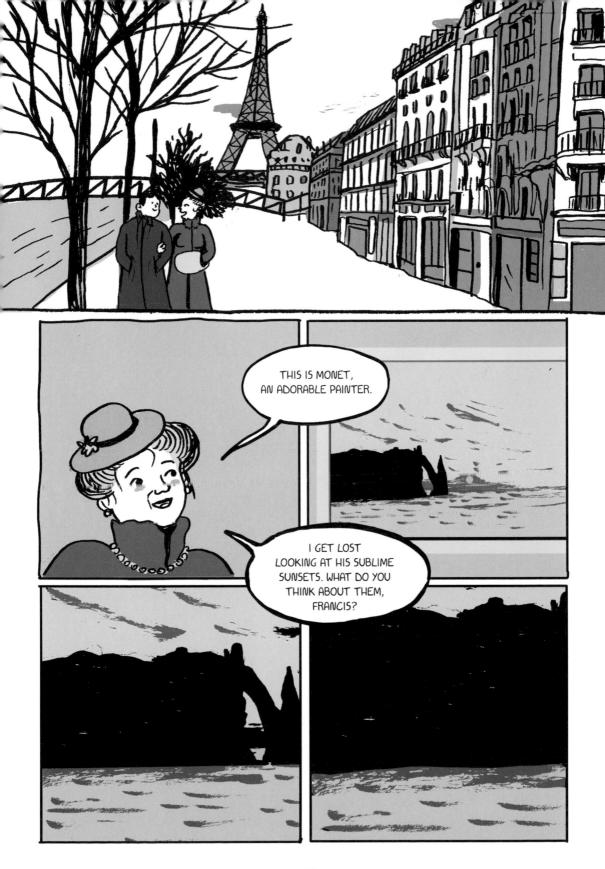

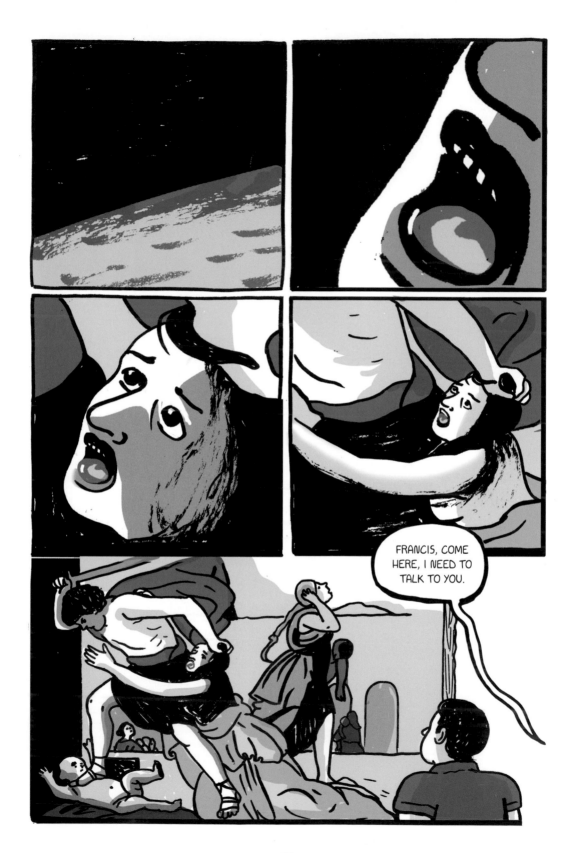

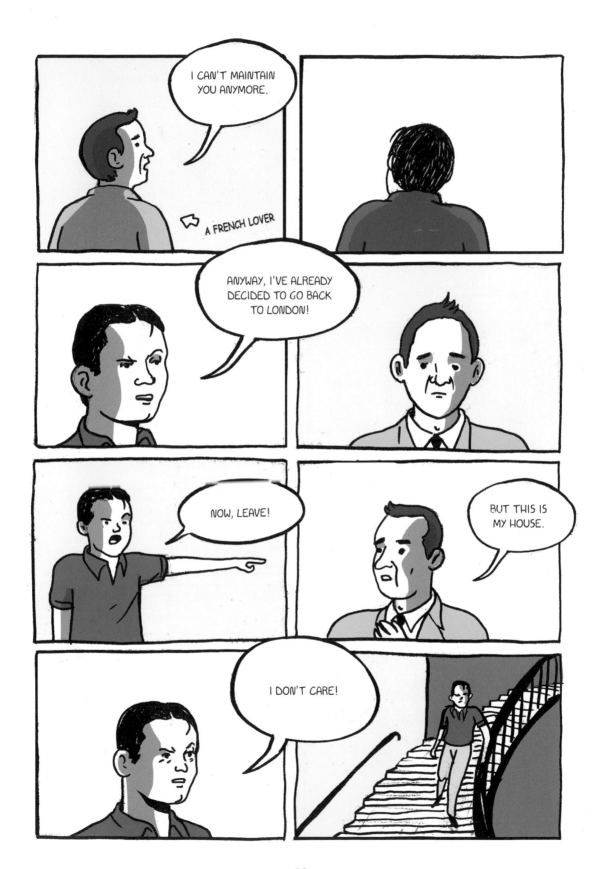

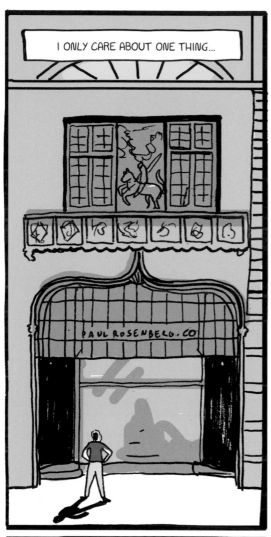

I ONLY CARE ABOUT ONE THING...

PAUL ROSENBERG.CO

... PAINTING.

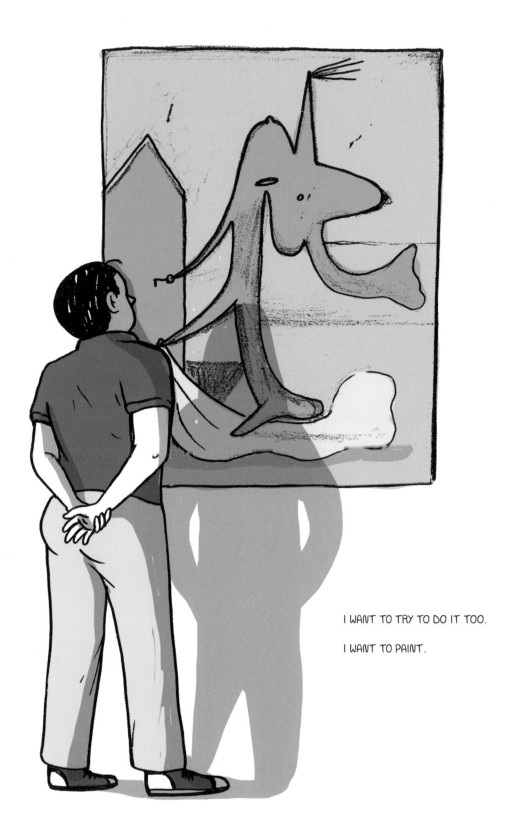

I WANT TO TRY TO DO IT TOO.

I WANT TO PAINT.

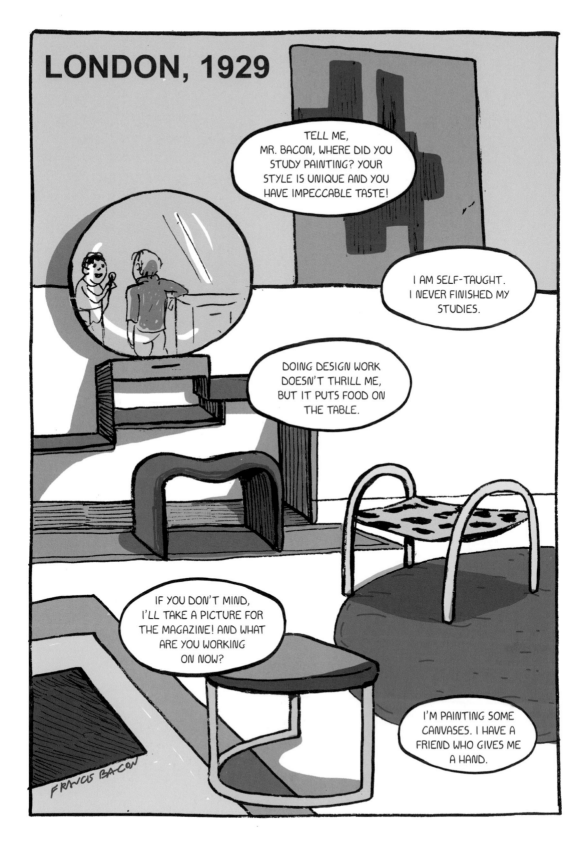

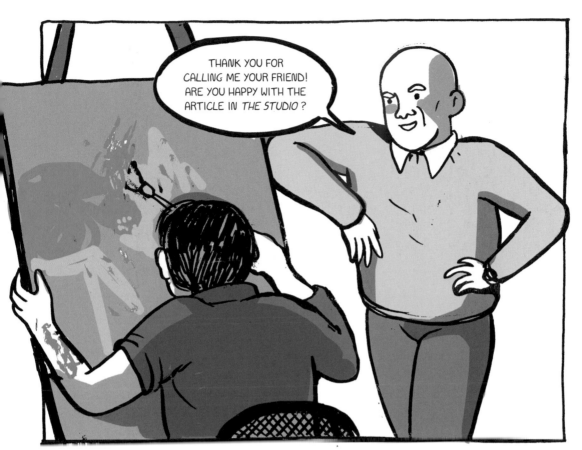

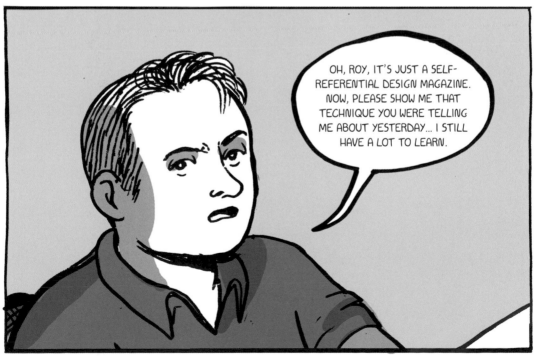

When you're young you can always get by... at least if you're clever. Francis takes painting lessons from Roy de Maistre and surrounds himself with other London artists.

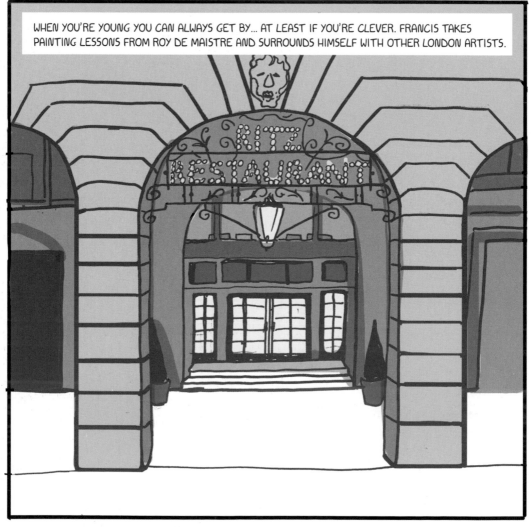

# THE BODY

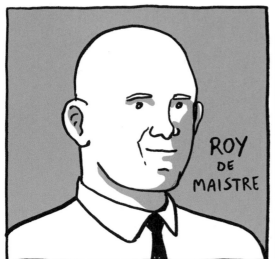

ROY DE MAISTRE

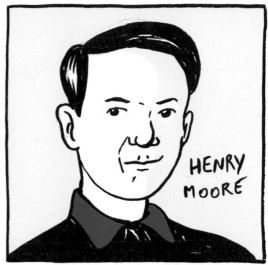

HENRY MOORE

GRAHAM SUTHERLAND

DOUGLAS COOPER

PATRICK WHITE

ERIC HALL

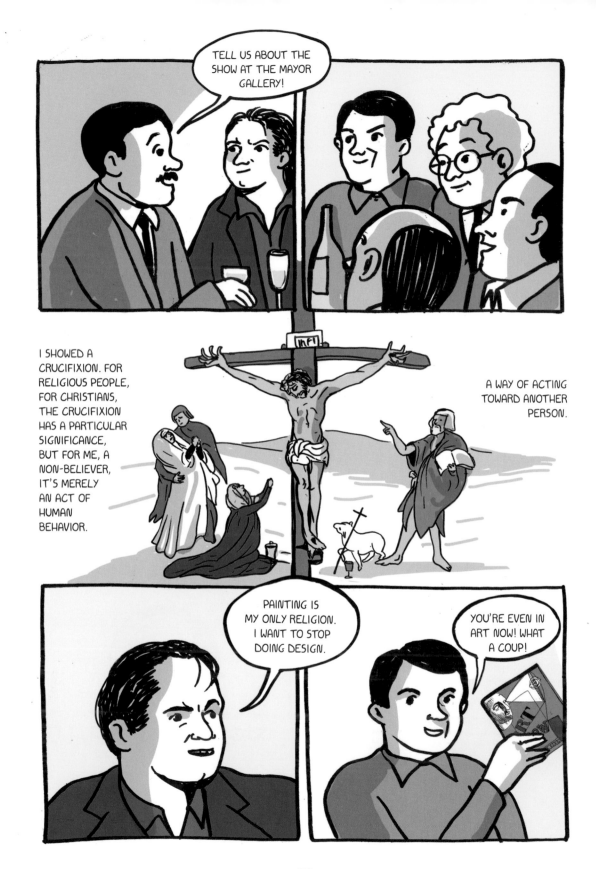

38

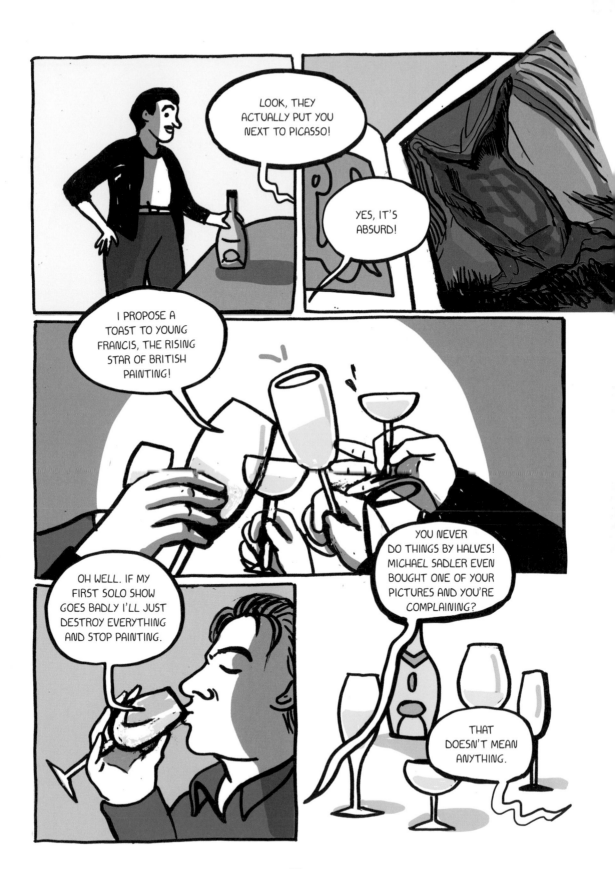

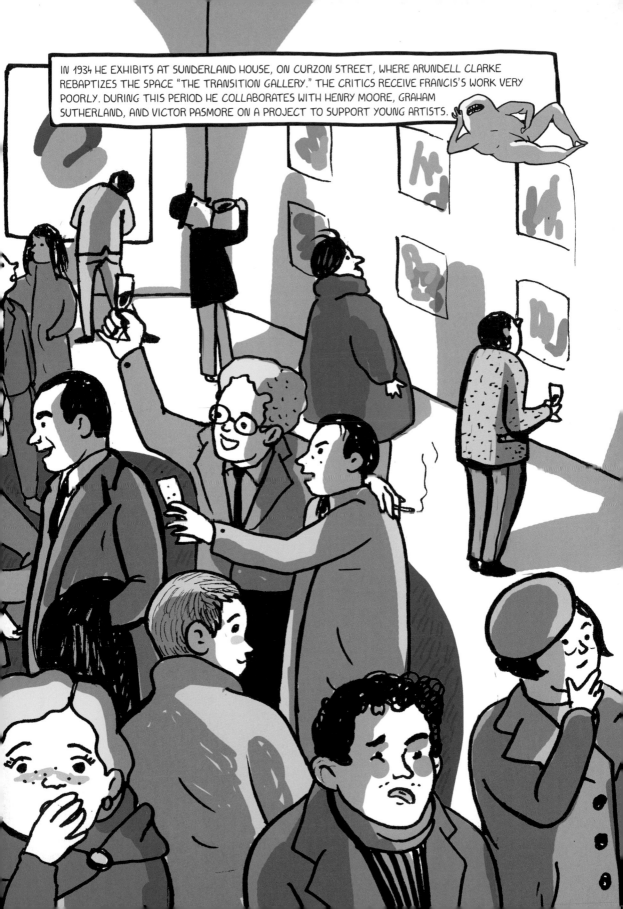

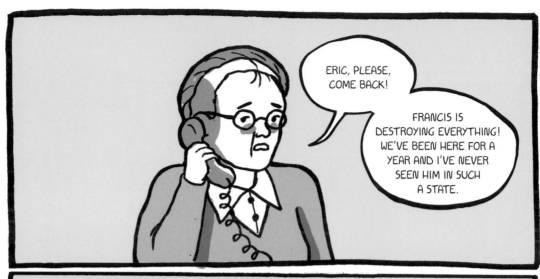

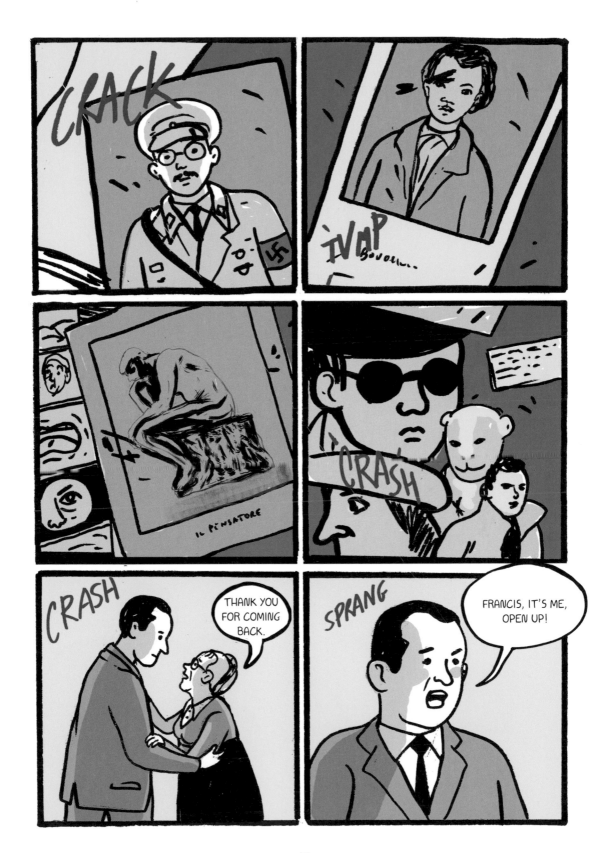

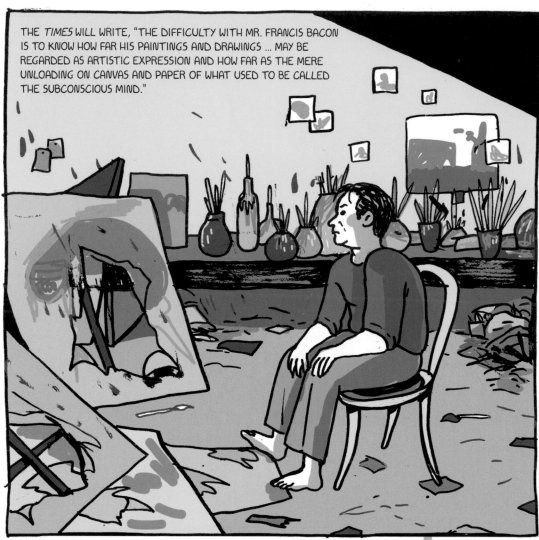

THE *TIMES* WILL WRITE, "THE DIFFICULTY WITH MR. FRANCIS BACON IS TO KNOW HOW FAR HIS PAINTINGS AND DRAWINGS ... MAY BE REGARDED AS ARTISTIC EXPRESSION AND HOW FAR AS THE MERE UNLOADING ON CANVAS AND PAPER OF WHAT USED TO BE CALLED THE SUBCONSCIOUS MIND."

44

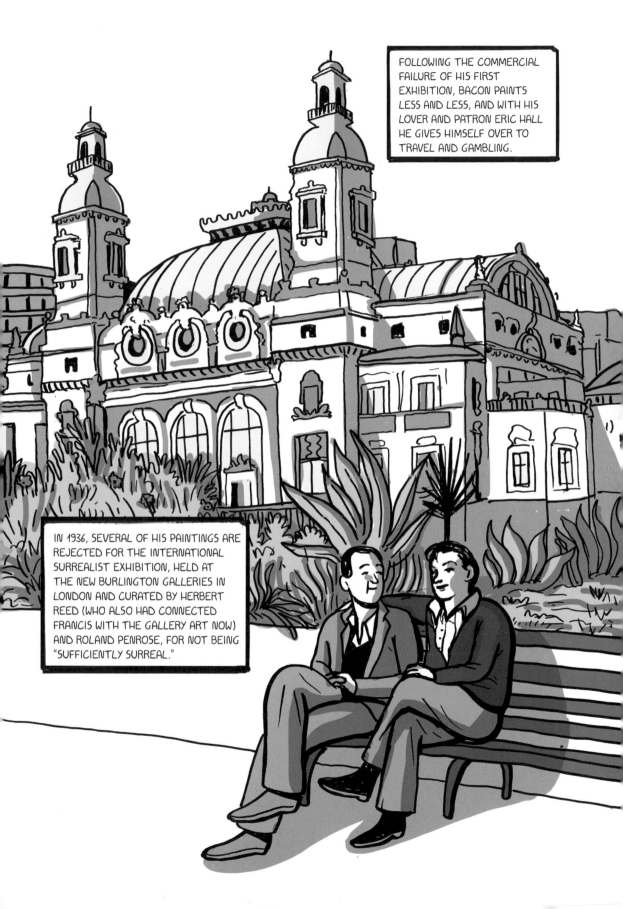

FOLLOWING THE COMMERCIAL FAILURE OF HIS FIRST EXHIBITION, BACON PAINTS LESS AND LESS, AND WITH HIS LOVER AND PATRON ERIC HALL HE GIVES HIMSELF OVER TO TRAVEL AND GAMBLING.

IN 1936, SEVERAL OF HIS PAINTINGS ARE REJECTED FOR THE INTERNATIONAL SURREALIST EXHIBITION, HELD AT THE NEW BURLINGTON GALLERIES IN LONDON AND CURATED BY HERBERT REED (WHO ALSO HAD CONNECTED FRANCIS WITH THE GALLERY ART NOW) AND ROLAND PENROSE, FOR NOT BEING "SUFFICIENTLY SURREAL."

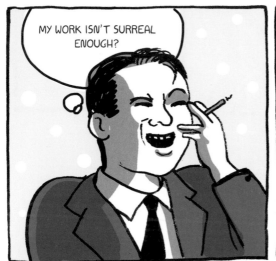

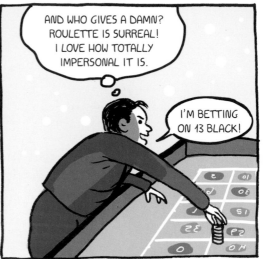

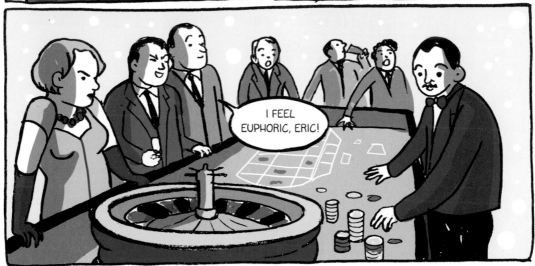

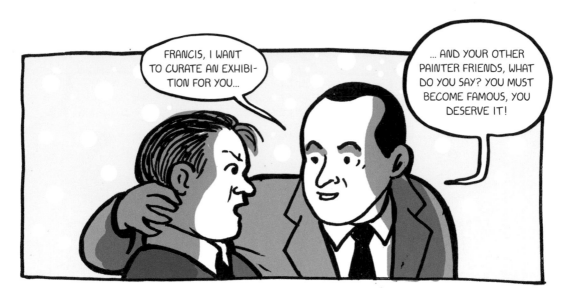

# ... 13 BLACK!

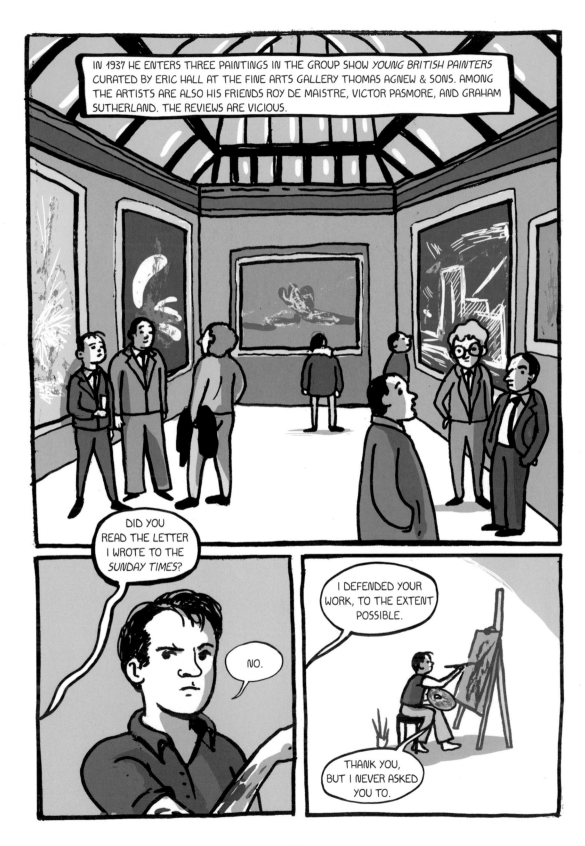

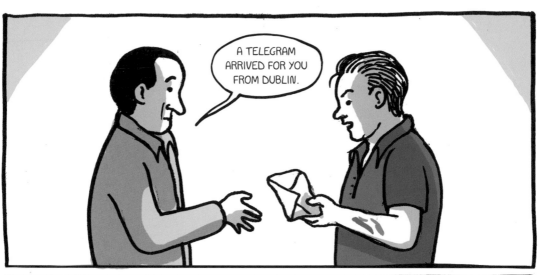

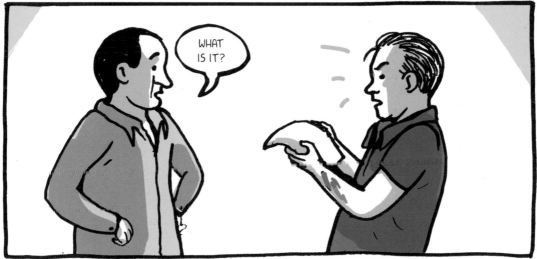

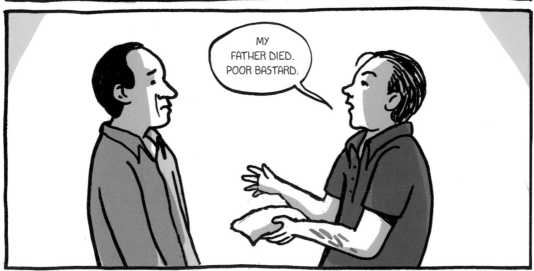

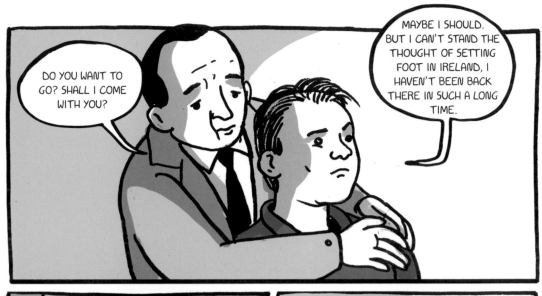

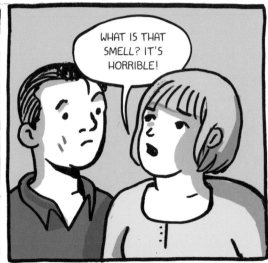

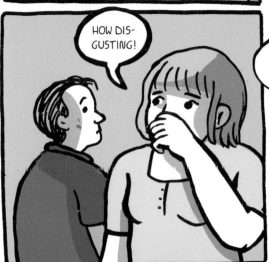

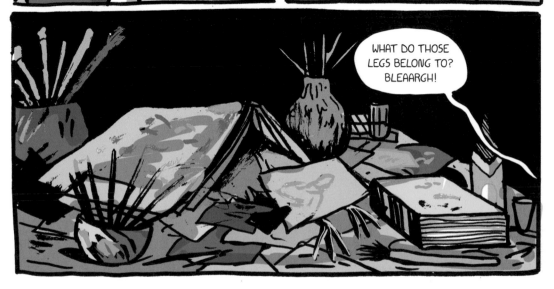

LONDON, 1939–1943

# THE FLESH

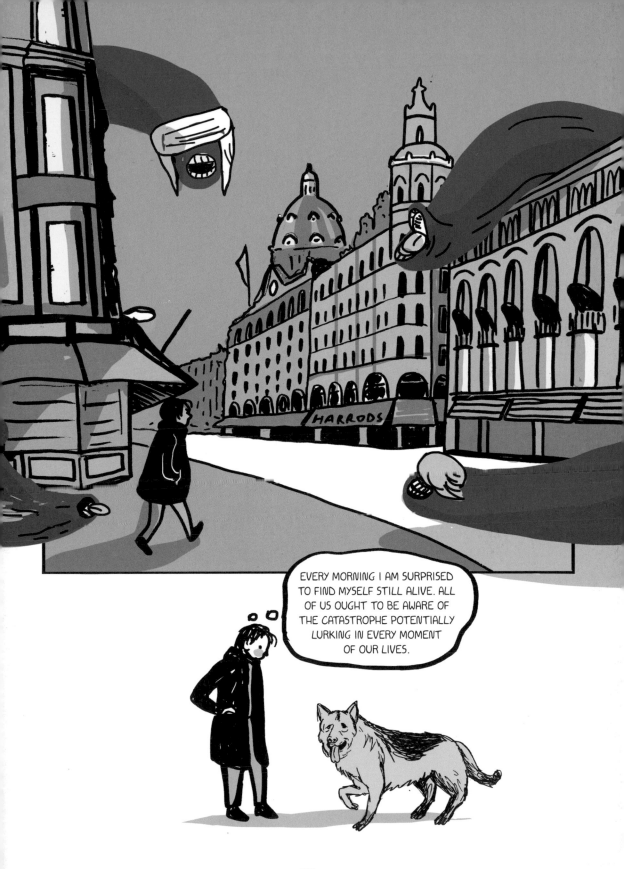

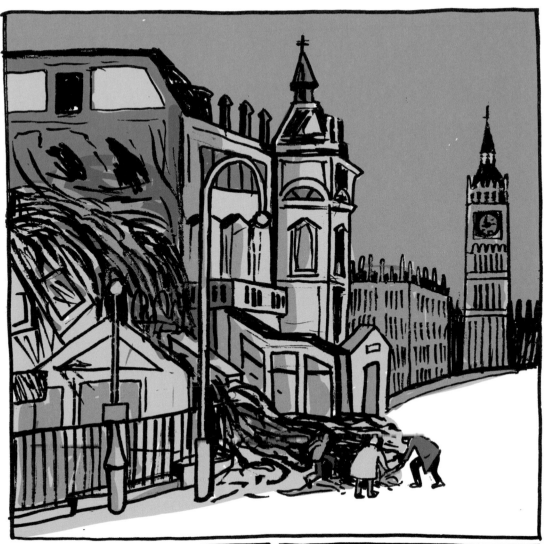

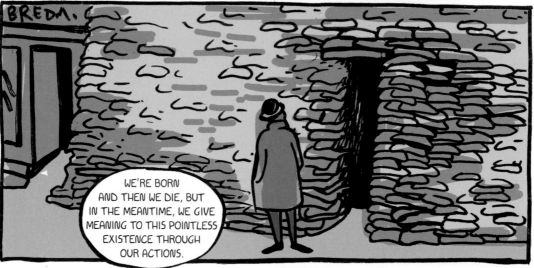

WE'RE BORN AND THEN WE DIE, BUT IN THE MEANTIME, WE GIVE MEANING TO THIS POINTLESS EXISTENCE THROUGH OUR ACTIONS.

BREDA.

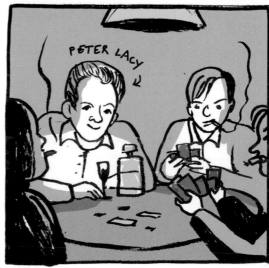

PETER LACY

AFTER THE WAR, FRANCIS RETURNS TO LONDON AND RENTS THE STUDIO AT NUMBER 7 CROMWELL PLACE, PREVIOUSLY USED BY THE PRE-RAPHAELITE PAINTER JOHN EVERETT MILLAIS.

HI FRANCIS, I BROUGHT A FRIEND WITH ME.

THAT CRITIC I TOLD YOU ABOUT.

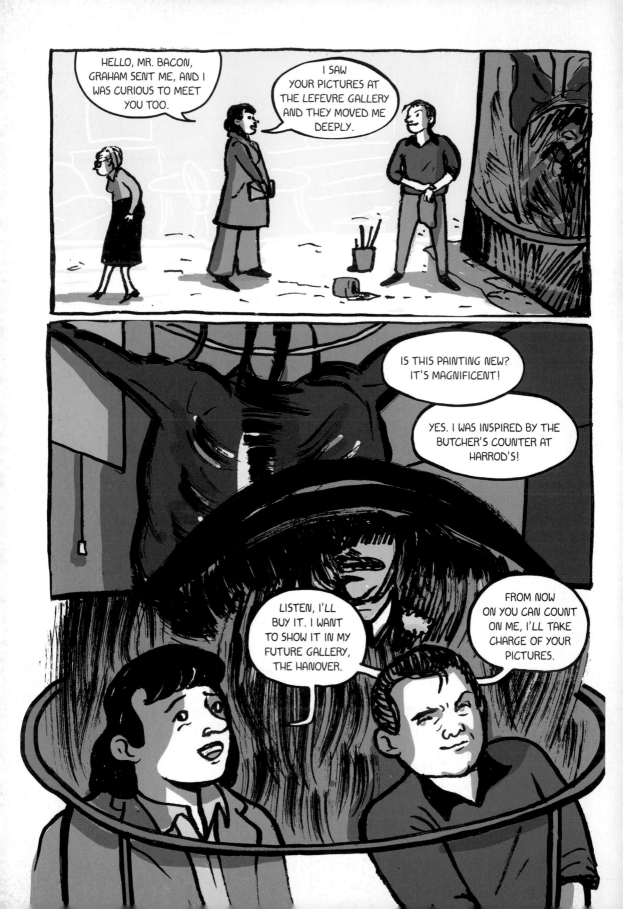

WHENEVER I ENTER A BUTCHER'S SHOP I'M ALWAYS SURPRISED THAT IT'S NOT ME THAT'S HUNG UP THERE, IN PLACE OF THE ANIMAL. SLAUGHTERHOUSES SEEM TO ME TO BE DIRECTLY CONNECTED WITH THE CRUCIFIXION. WHAT ARE WE BESIDES POTENTIAL CARCASSES?

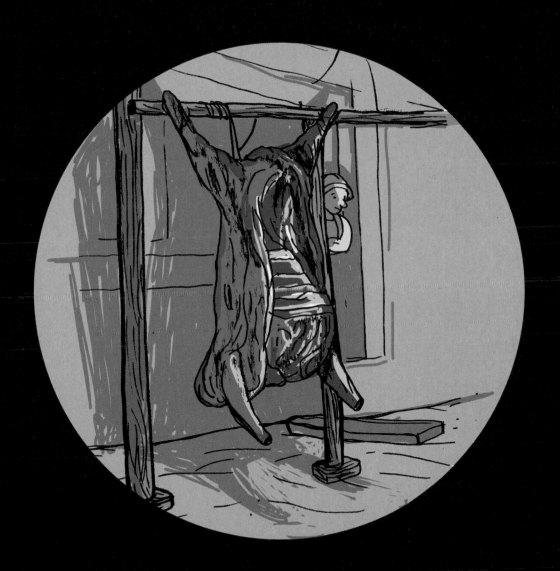

DEAR ERICA, THANKS AGAIN FOR ALL THE SUPPORT YOU GIVE ME, WHICH
ALLOWS ME TO STAY IN THESE MAGNIFICENT PLACES. MY ASTHMA IS DOING
MUCH BETTER, THANK YOU, AND I HAVE FINISHED FOUR CANVASES, MY BEST
SO FAR. I AM EXCITED ABOUT THEM.

DO TELL ARTHUR I HAVE NOT BEEN ABLE TO TRACK DOWN THE
MOVEMENTS OF THE FLEET YET. I DO HOPE YOU ARE FEELING BETTER.
IT IS WONDERFUL HERE TERRIBLY EXPENSIVE AND THE DAYS HOT AND
TREMBLING LIKE THE MIDDLE OF SUMMER.

I HAVE FOUND A VILLA WITH WHAT I HOPE WILL BE A WONDERFUL ROOM TO WORK IN...
THERE ARE PLENTY OF ROOMS AND BATHROOMS SO DO COME AND STAY IF YOU FEEL LIKE
IT ANY TIME. I SAW GRAHAM AND KATHY AND EARDLEY LAST NIGHT.

SEE YOU SOON.

MUCH LOVE,
FRANCIS.

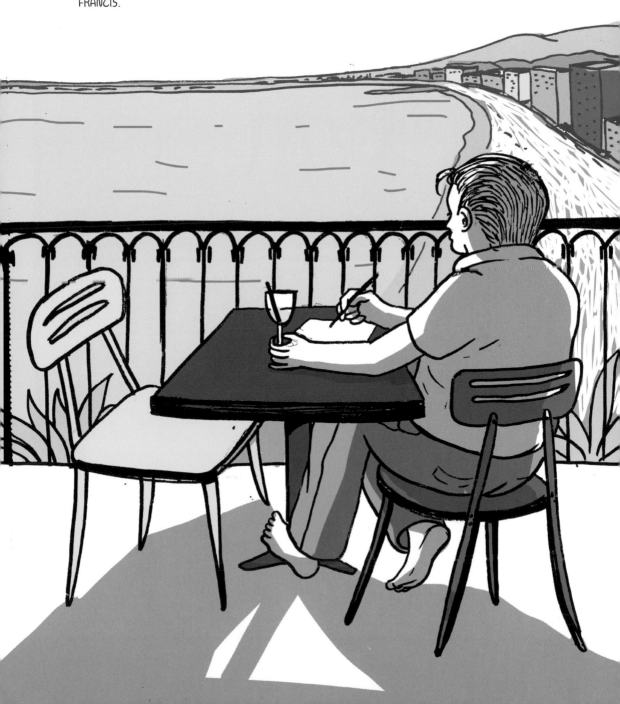

# THE SPIRIT

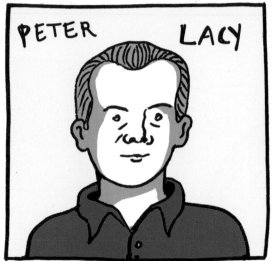

PETER LACY

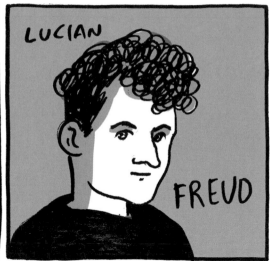

LUCIAN FREUD

ERICA BRAUSEN

DANIEL FARSON

DAVID SYLVESTER

MURIEL BELCHER

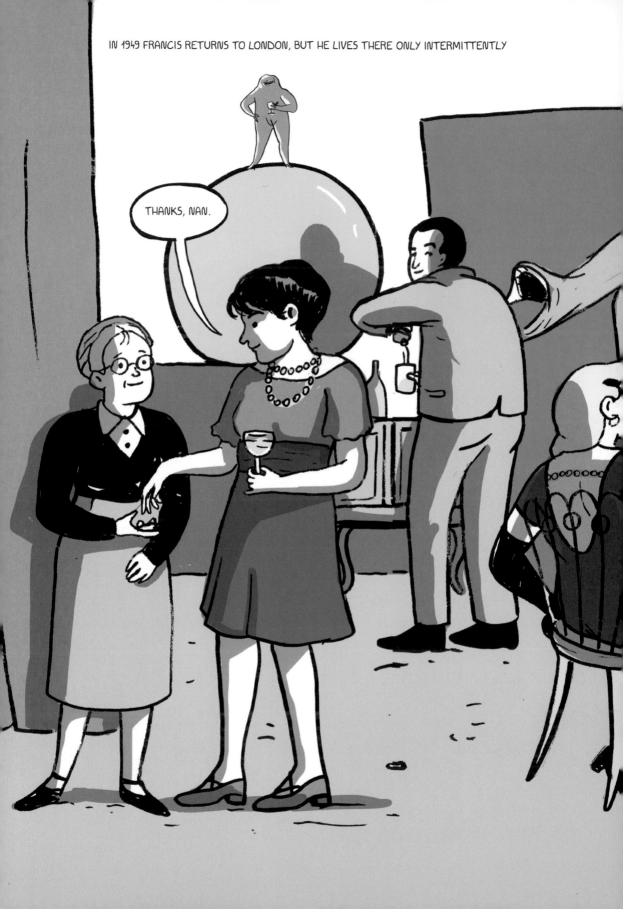

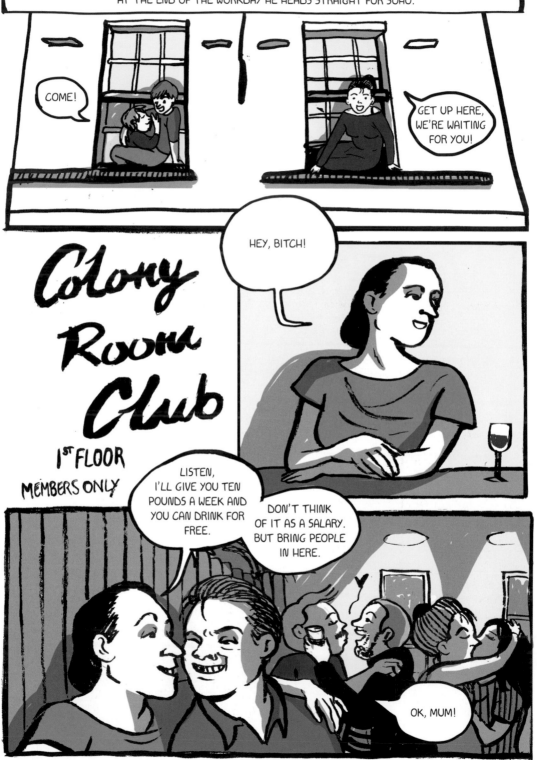

THE HANOVER GALLERY DEDICATES ITS FIRST MAJOR SOLO EXHIBITION TO HIM. IN THE REVIEWS HE IS EQUALLY PRAISED AND PANNED.

BACON AFFIRMS THAT HE HAS DESTROYED 100 PIECES, BUT HE IS STILL ABLE TO EXHIBIT IN VARIOUS COLLECTIVES IN ENGLAND AND THE UNITED STATES.

IN THE FIRST HALF OF THE 1950s FRANCIS LIVES A NOMAD'S LIFE. THE NATURE OF A PAINTER LOOKING FOR SUCCESS.

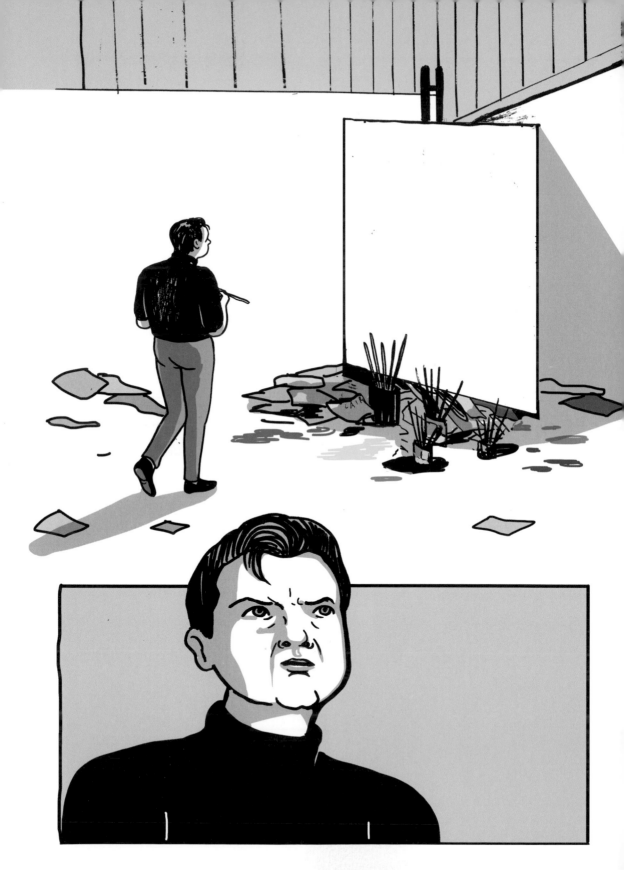

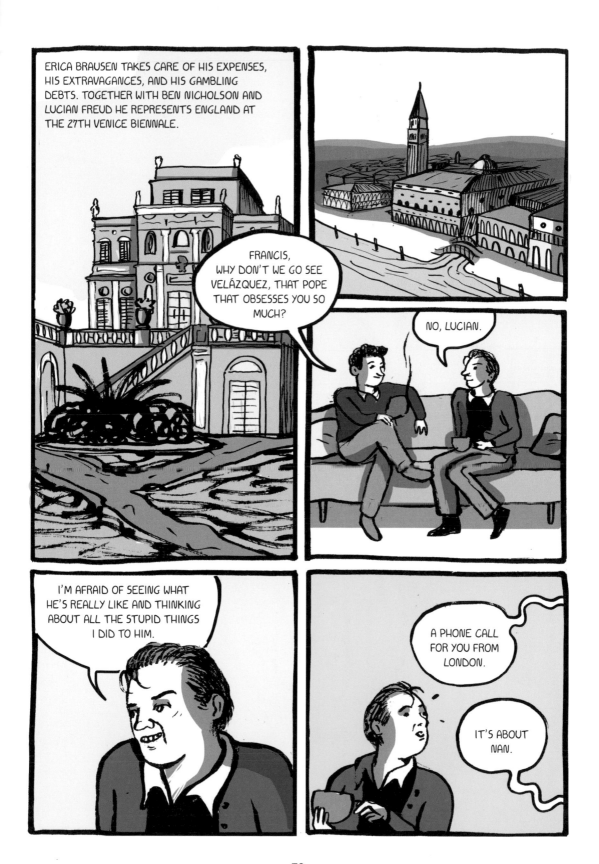

ERICA BRAUSEN TAKES CARE OF HIS EXPENSES, HIS EXTRAVAGANCES, AND HIS GAMBLING DEBTS. TOGETHER WITH BEN NICHOLSON AND LUCIAN FREUD HE REPRESENTS ENGLAND AT THE 27TH VENICE BIENNALE.

FRANCIS, WHY DON'T WE GO SEE VELÁZQUEZ, THAT POPE THAT OBSESSES YOU SO MUCH?

NO, LUCIAN.

I'M AFRAID OF SEEING WHAT HE'S REALLY LIKE AND THINKING ABOUT ALL THE STUPID THINGS I DID TO HIM.

A PHONE CALL FOR YOU FROM LONDON.

IT'S ABOUT NAN.

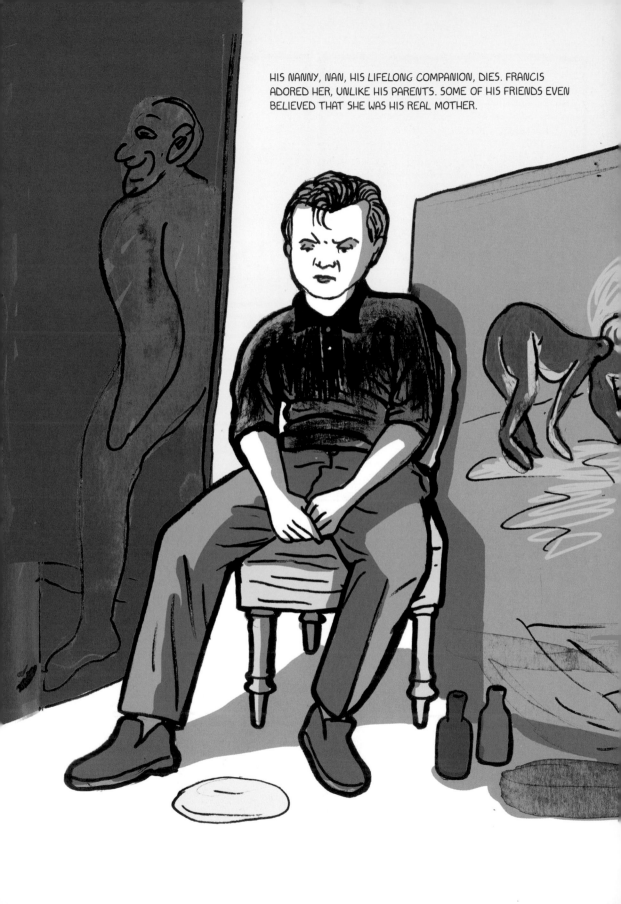

HIS NANNY, NAN, HIS LIFELONG COMPANION, DIES. FRANCIS ADORED HER, UNLIKE HIS PARENTS. SOME OF HIS FRIENDS EVEN BELIEVED THAT SHE WAS HIS REAL MOTHER.

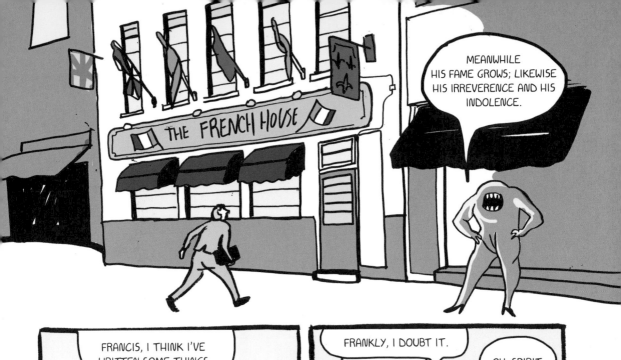

Meanwhile his fame grows; likewise his irreverence and his indolence.

Francis, I think I've written some things you might like.

Oh, yes.

Frankly, I doubt it.

Oh yes, they have spirit!

Oh, spirit...

THE SPIRIT OF BOLLOCKS

HAHA

HAHA HAHA

The poor guy!

You're awful!

HAHA HAHA

HAHA HAHA

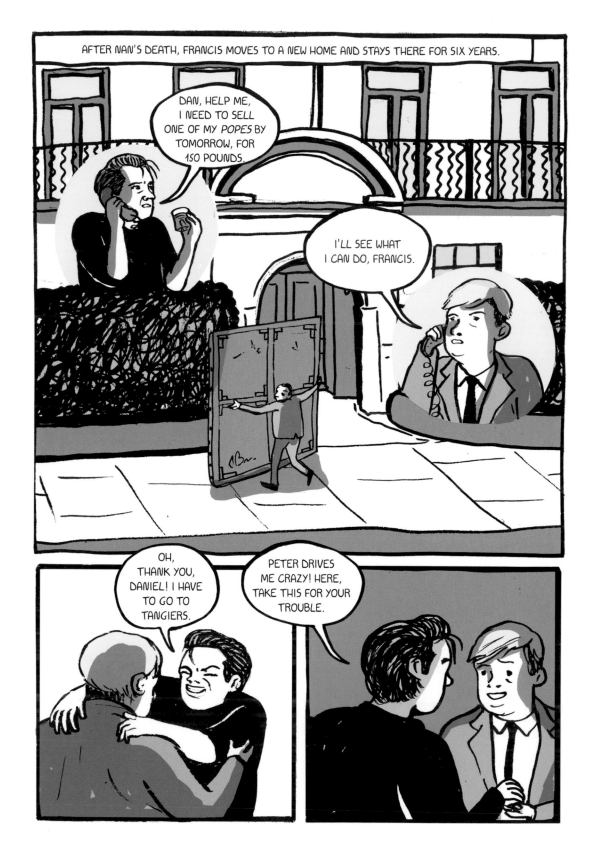

I BELIEVE THAT ART IS ESSENTIAL, FOR IT IS TO ART THAT ALL THE GREAT ASPIRATIONS OF MANKIND HAVE BEEN CONSIGNED.

WE WOULD KNOW NOTHING OF PAST CIVILIZATIONS HAD IT NOT BEEN FOR THE TRACES THEY LEFT US IN THEIR WORKS OF ART.

BACON ARRIVES IN TANGIERS FOR THE FIRST TIME, IN THE WHITE ROLLS-ROYCE OF PETER POLLOCK. HE WILL RETURN THERE REGULARLY FOR THE NEXT SIX YEARS.

FAMOUS SOUTH AFRICAN CRICKET PLAYER

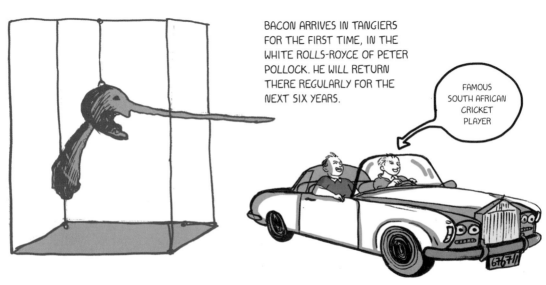

HE OFTEN STAYS AT THE HOTEL MANDRIA, WHERE HE MEETS THE WRITERS OF
THE BEAT GENERATION. NUMEROUS BROTHELS OFFER ATTRACTIVE YOUNG BOYS,
AND THIS DEBAUCHERY IS AN INCENTIVE FOR THOSE WHO ENJOY THE RISK.

IN 1957 HOMOSEXUAL ACTS BETWEEN ADULTS ARE DECRIMINALIZED IN ENGLAND. BACON DOESN'T CARE: HE LOVES THE AURA OF THE ILLICIT THAT ACCOMPANIES BEHAVIORS THAT ARE NECESSARILY CLANDESTINE. HE SIGNS A CONTRACT WITH THE MARLBOROUGH FINE ART GALLERY FOR THE SALE OF HIS WORK.

IN THE SPRING OF 1962 THE TATE GALLERY IN LONDON HOSTS A RETROSPECTIVE FEATURING 91 PAINTINGS THAT DEFINES HIM AS ONE OF THE GREATEST PAINTERS OF HIS TIME.

OH MY GOD, FRANCIS, I AM SO SORRY TO HAVE TO GIVE YOU THIS TELEGRAM NOW, OF ALL TIMES.

IT'S PETER... HE'S DEAD.

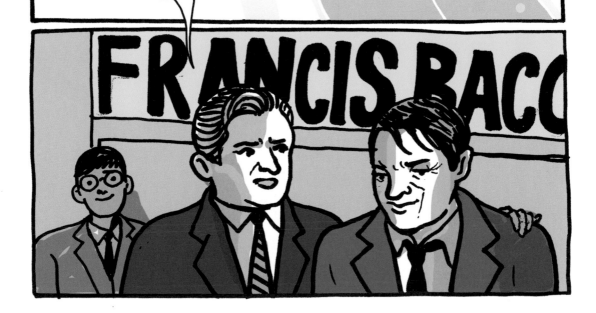

FRANCIS BACO

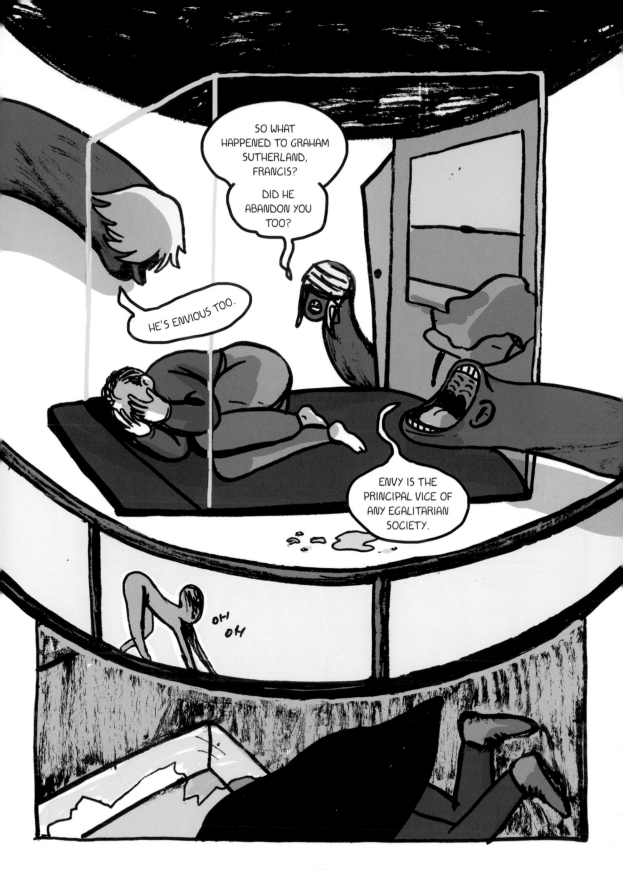

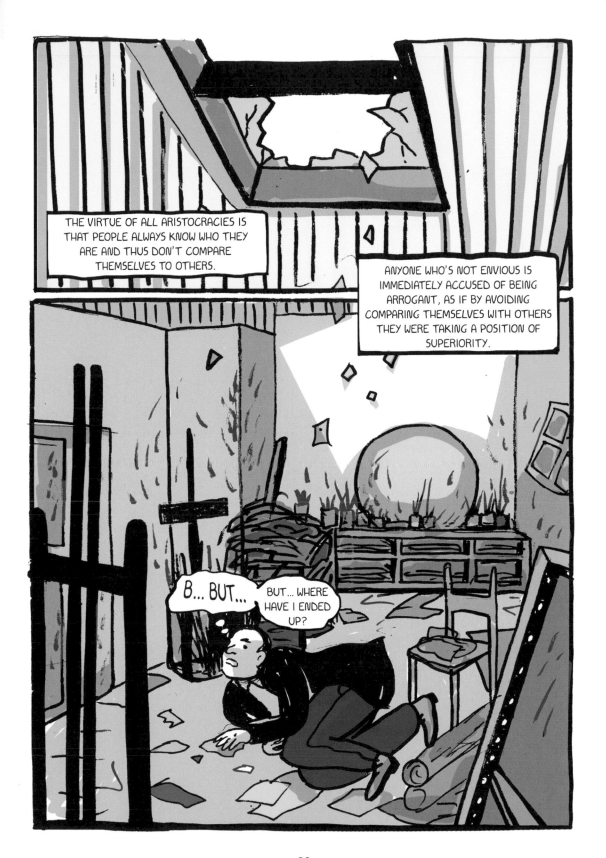

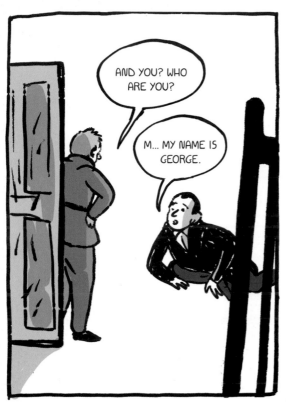

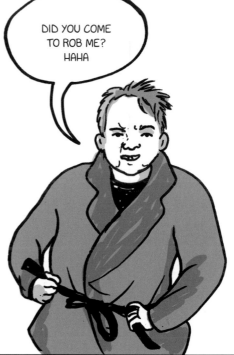

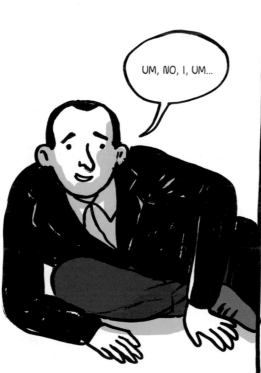

# THE VIRTUE

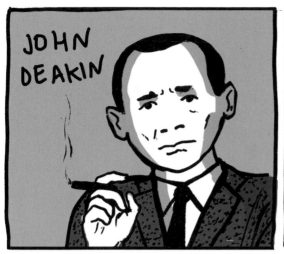

JOHN DEAKIN

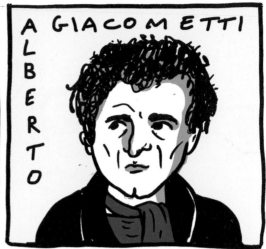

ALBERTO GIACOMETTI

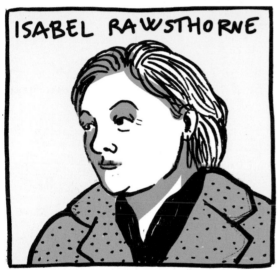

ISABEL RAWSTHORNE

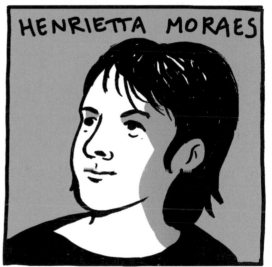

HENRIETTA MORAES

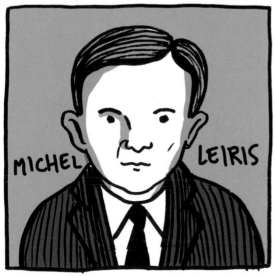

MICHEL LEIRIS

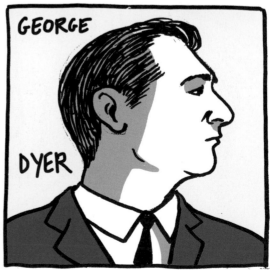

GEORGE DYER

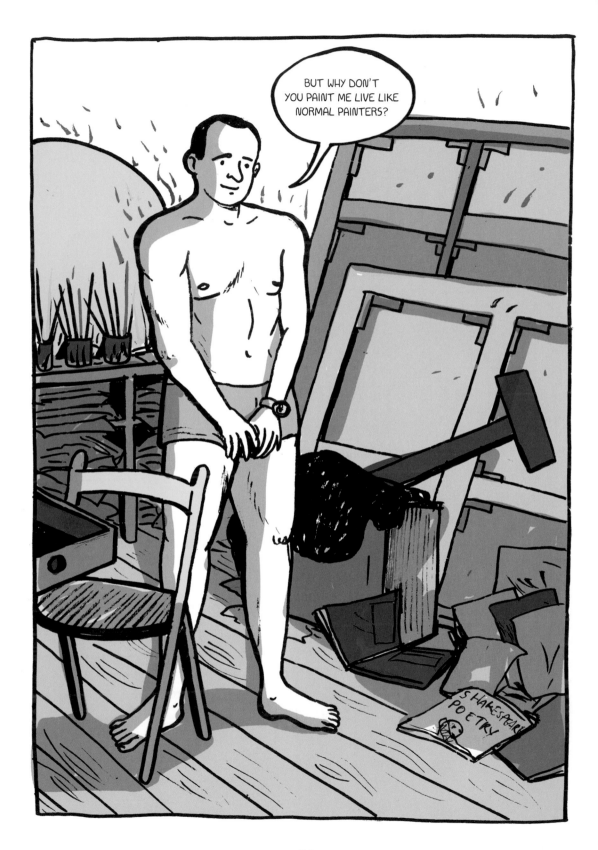

94

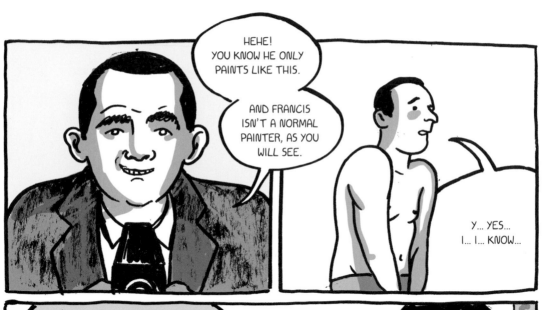

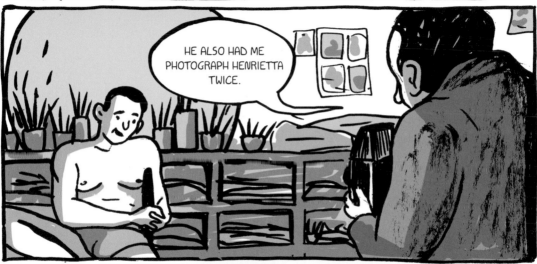

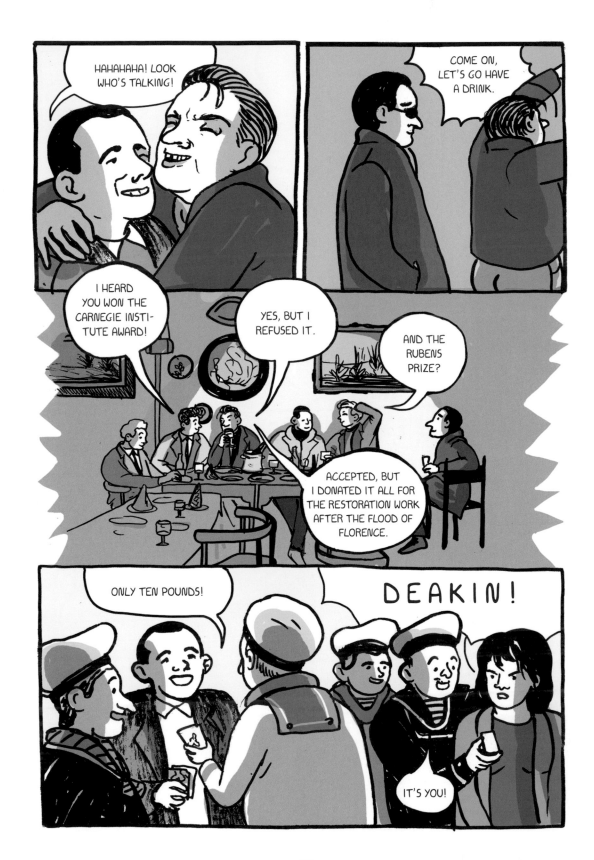

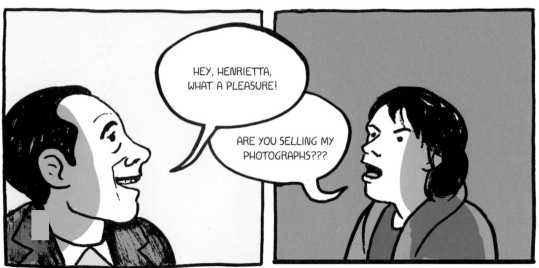

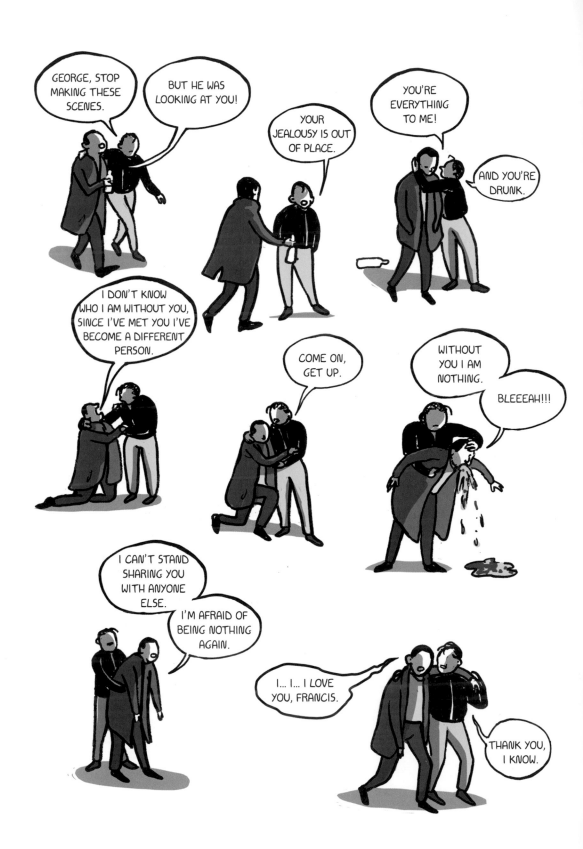

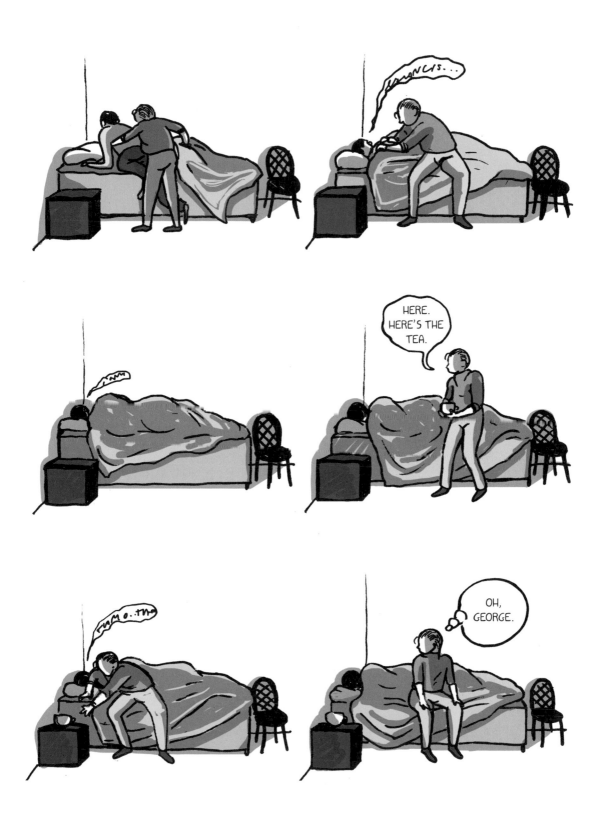

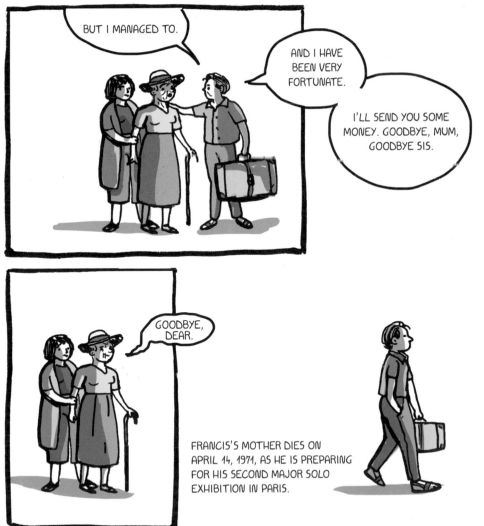

FRANCIS'S MOTHER DIES ON APRIL 14, 1971, AS HE IS PREPARING FOR HIS SECOND MAJOR SOLO EXHIBITION IN PARIS.

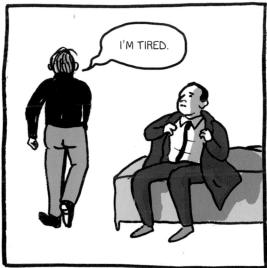
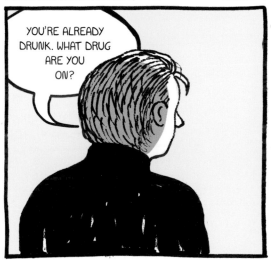
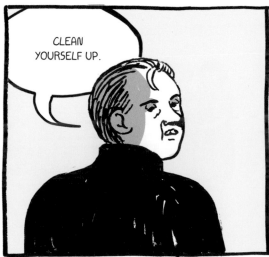

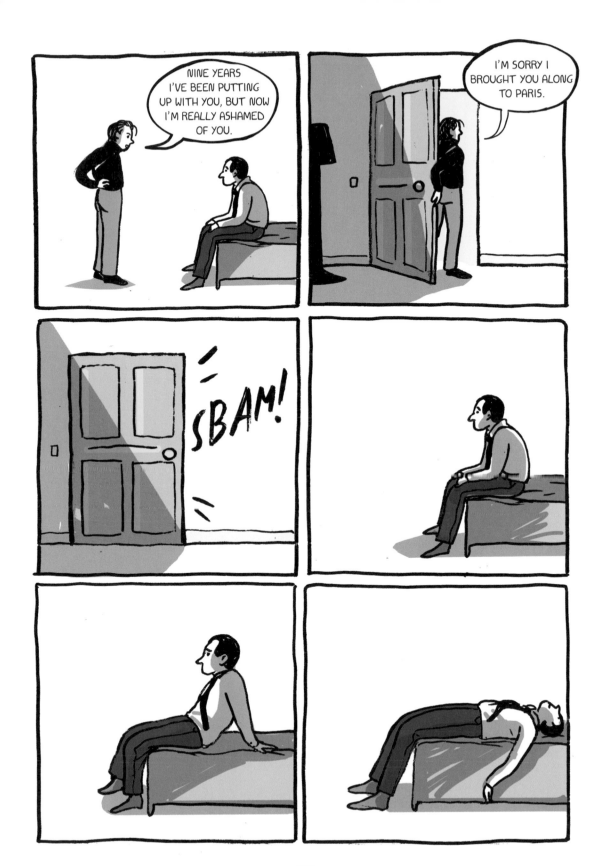

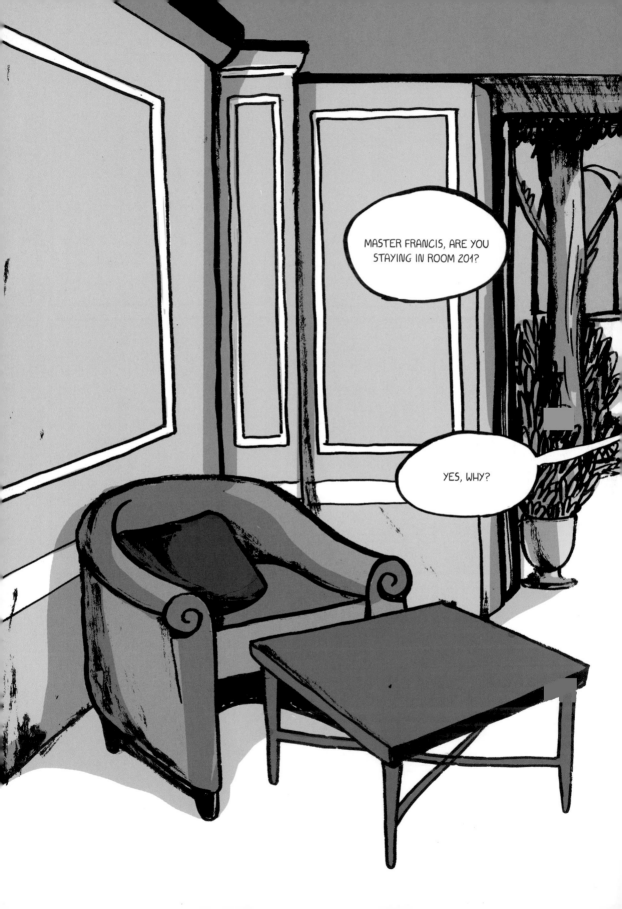

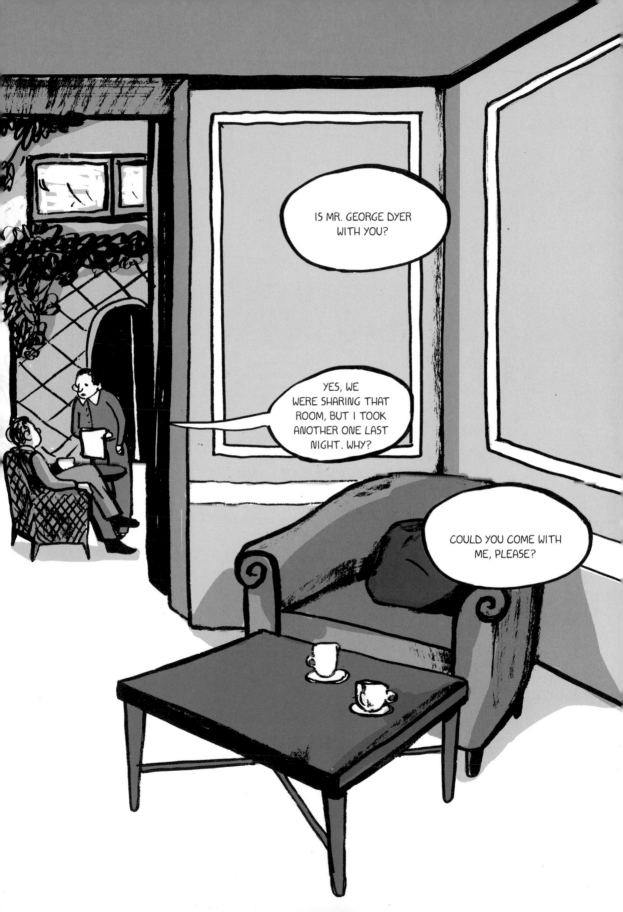

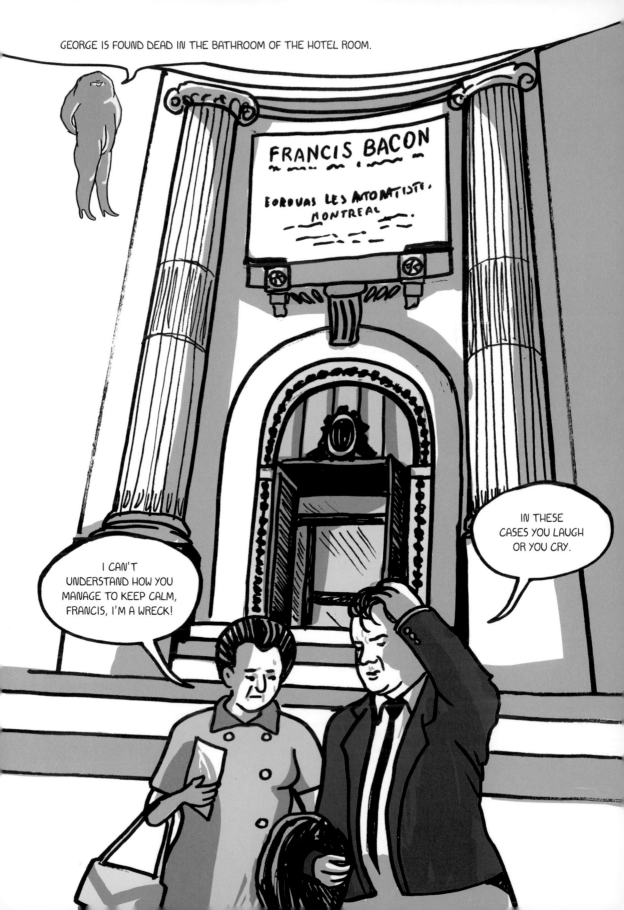

IMAGINE HOW HAPPY THEY'LL ALL BE.

HELLO THERE! WHAT'S NEW?

BLAAAAAH

BUT WHY IS EVERYONE CRYING?

WHERE IS THAT LUCKY BITCH?

CLAF

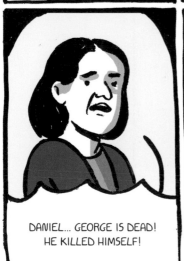

DANIEL... GEORGE IS DEAD! HE KILLED HIMSELF!

OH, NO... AND WHERE IS FRANCIS?

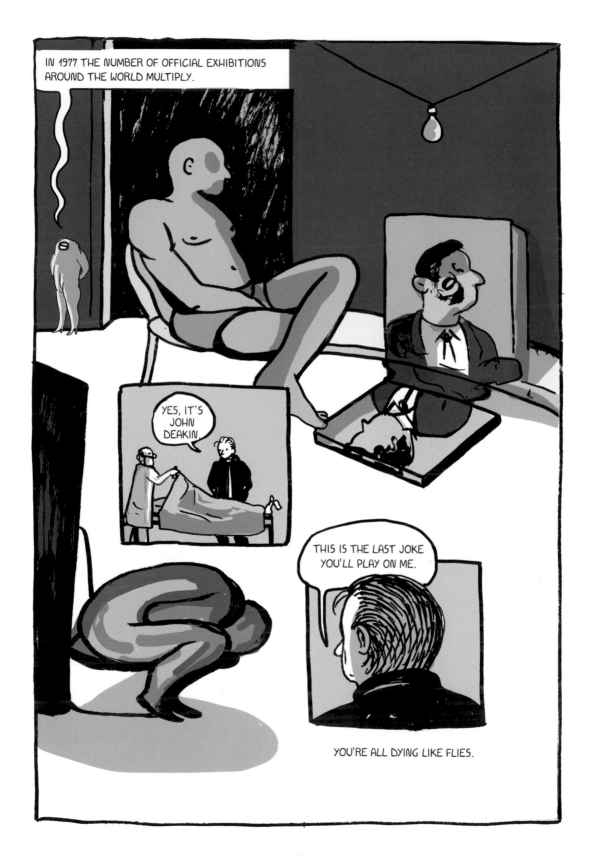

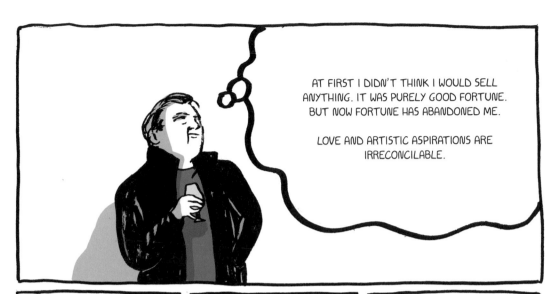

AT FIRST I DIDN'T THINK I WOULD SELL ANYTHING. IT WAS PURELY GOOD FORTUNE. BUT NOW FORTUNE HAS ABANDONED ME.

LOVE AND ARTISTIC ASPIRATIONS ARE IRRECONCILABLE.

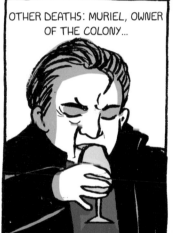

OTHER DEATHS: MURIEL, OWNER OF THE COLONY...

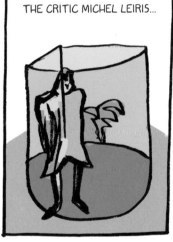

THE CRITIC MICHEL LEIRIS...

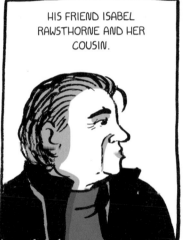

HIS FRIEND ISABEL RAWSTHORNE AND HER COUSIN.

FRANCIS EXHIBITS AT THE MARLBOROUGH GALLERY IN NEW YORK AND THE TATE GALLERY IN LIVERPOOL.

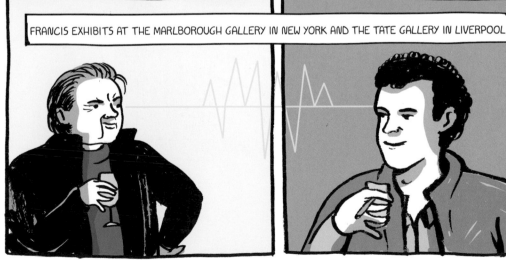

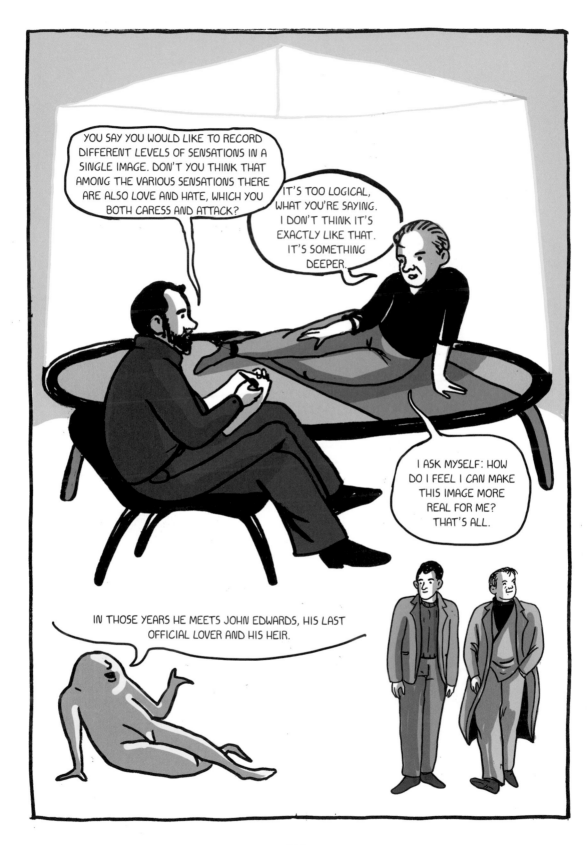

MUSEO DEL PRADO, MADRID

I HAVE ALWAYS THOUGHT OF FRIENDSHIP AS A SITUATION IN WHICH TWO PEOPLE DEMOLISH EACH OTHER AND PERHAPS LEARN SOMETHING IN THE PROCESS. THAT'S WHY, WHEN PEOPLE PRAISE YOU, EVEN THOUGH IT'S PLEASANT, IT DOESN'T HELP YOU AT ALL.

SHALL WE GO HAVE A DRINK?

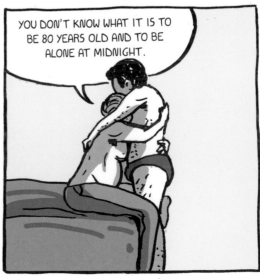

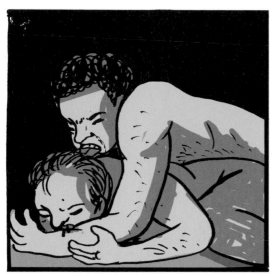
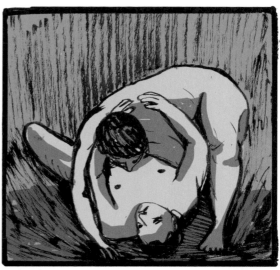
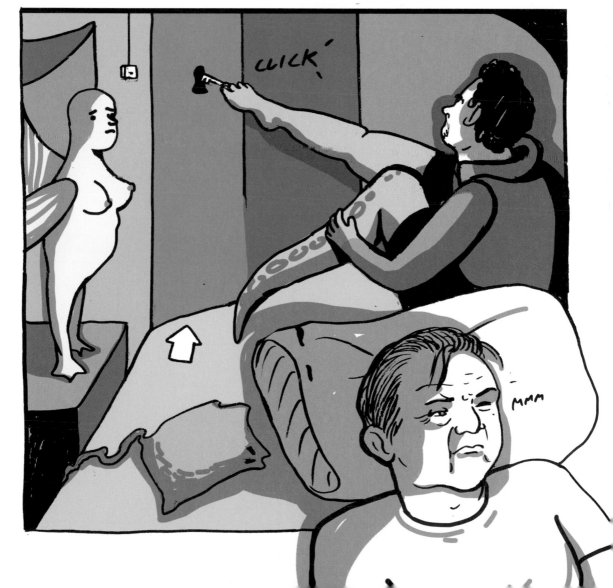

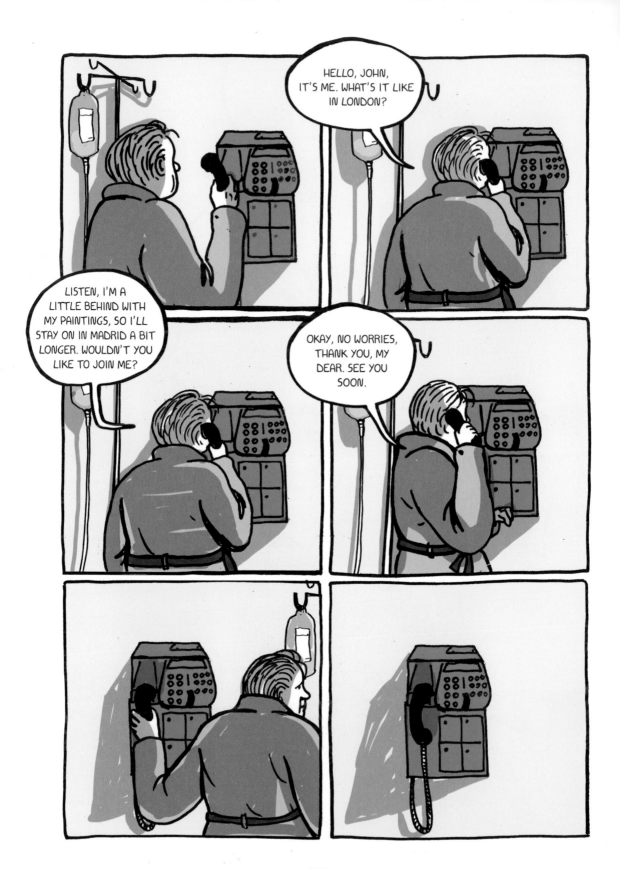

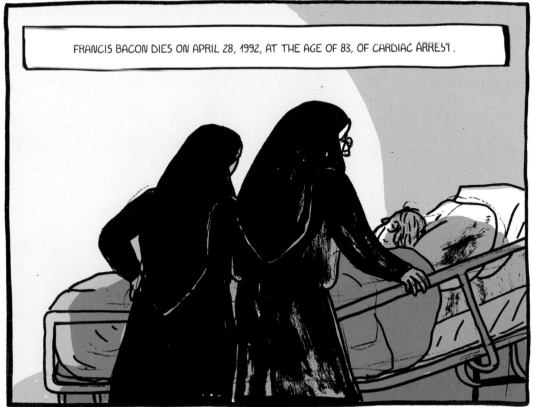

MICHAEL PEPPIATT WRITES, "BY A STRANGE TURN OF FATE, HE WAS LOOKED AFTER IN HIS LAST MOMENTS BY TWO NUNS BELONGING TO THE ORDER OF THE SERVANTS OF MARY; TO DIE AMONGST NUNS HAD BEEN BACON'S WORST NIGHTMARE, AND IT HAD HAPPENED. YET HE HAD BEEN TREATED IN THE CLINIC BY THE SAME SISTERS ON PREVIOUS OCCASIONS, AND HE SPOKE FONDLY OF THEM."

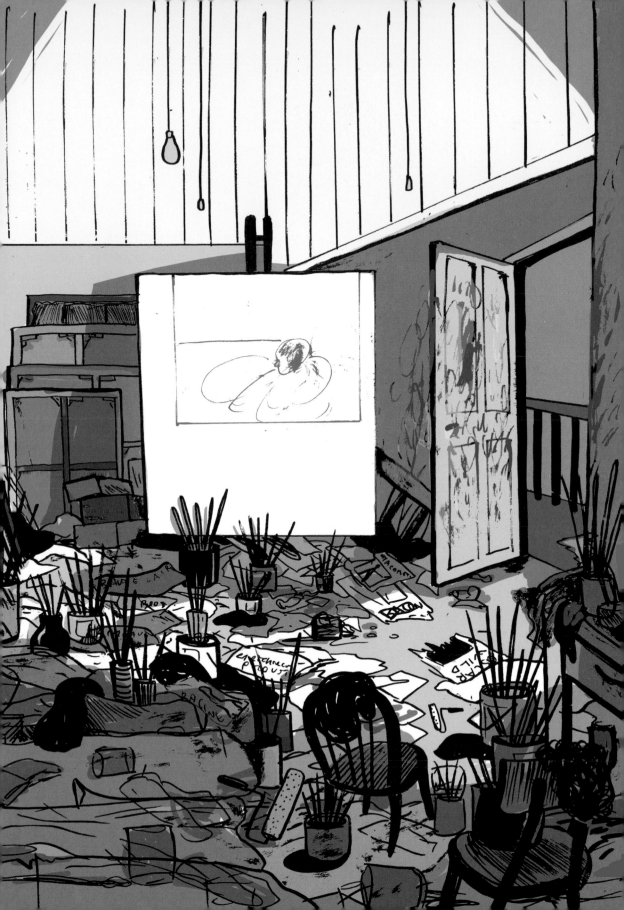

I WOULD LIKE MY PICTURES TO LOOK AS IF A HUMAN BEING HAD PASSED BETWEEN THEM,
LIKE A SNAIL, LEAVING A TRAIL OF THE HUMAN PRESENCE AND MEMORY TRACE OF PAST EVENTS
AS THE SNAIL LEAVES ITS SLIME.

# AFTERWORD

I apologize to all the protagonists from those incredible years who knew Francis personally, who accompanied him in more or less long periods of his life or made an important contribution to his life, but who nonetheless were not given space within this story.

People leave so many traces, for better and for worse, that it is impossible to include them all in a graphic novel like this. Even with the presumption of creating a biography, all one can do is to suggest and recreate (just as Francis did in his works) an idea of what a life has been: nothing more than the sensation of reality.

# THE BODY

**ROY DE MAISTRE** Mentor and teacher of Francis in London in the early 1930s.

**HENRY MOORE** Along with Graham Sutherland, one of the most important painters of the period.

**GRAHAM SUTHERLAND** Friend and supporter of Francis; shares with him and Henry Moore a number of exhibitions at the Gallery Lefevre.

**DOUGLAS COOPER** Commissioned interior designs by Francis; one of the best-known collectors of modern art in all of England.

**PATRICK WHITE** Australian writer, lover of Roy De Maistre.

**ERIC HALL** Wealthy businessman who leaves his family for Francis and supports him for a number of years.

# THE SPIRIT

**PETER LACY** Former hunting guide, earns his living playing music in the bars of Tangiers; establishes a tormented and violent relationship with Francis.

**LUCIAN FREUD** Close friend of Francis, with whom he shared many affinities as an artist. The two paint numerous portraits of each other and represent England at the 27th Venice Biennale.

**ERICA BRAUSEN** Head of the Hanover Gallery in London; meets Francis through Graham Sutherland.

**DANIEL FARSON** Writer and television personality; deeply involved in the art world and a witness to the ferment that shakes up British society in the 1950s and 1960s.

**DAVID SYLVESTER** Critic and curator of British art; very influential in promoting modern artists, in particular Francis Bacon, Joan Miró, and Lucian Freud.

**MURIEL BELCHER** A lesbian and a snob, she is the owner of the Colony Room in London, Soho's most famous club.

# THE VIRTUE

**JOHN DEAKIN** Photographer for *Vogue*, loves to dive into the strange and intellectual inebriation of Soho. Bacon considers the portraits of the drunk photographer superior to those of Nadar and of Julia Margaret Cameron.

**ALBERTO GIACOMETTI** Sculptor; one of the few artists with whom Francis feels an affinity and whom he regards as a great inspiration.

**ISABEL RAWSTHORNE** Also known as Isabel Lambert; a British painter, designer, and model. Plays a fundamental role in the friendship between Alberto Giacometti and Francis Bacon.

**HENRIETTA MORAES** Model and friend of Francis Bacon and John Deakin, lover of Lucian Freud.

**MICHEL LEIRIS** Ethnologist; writes the introduction to the 1966 Paris exhibition at the Gallery Maeght. Also the deus ex machina for the great exhibition of 1971 at the Grand Palais.

**GEORGE DYER** Simple man and occasional thief. Becomes attached to Francis in a relationship of sex and sadomasochism.

# BIBLIOGRAPHY

- Francis Bacon, *Francis Bacon in Conversation with Michel Archimbaud*, London 1993
- Gilles Deleuze, *Francis Bacon: The Logic of Sensation*, London and New York 2003
- Daniel Farson, *The Gilded Gutter Life of Francis Bacon*, London 1993
- Stefano Ferrari, *Lo specchio dell'io. Autoritratto e psicologia*, Rome and Bari 2002
- Nadia Fusini, *Beckett e Bacon. Il bene, il bello*, Milan 1993
- Martin Gayford, *Modernists and Mavericks: Bacon, Freud, Hockney and the London Painters*, London 2019
- Kitty Hauser (illustrations by Christina Christoforou), *This is Bacon*, London 2014
- Michel Leiris, *Francis Bacon: Full Face and in Profile*, London and New York 1983
- Jonathan Littell, *Three Studies After Francis Bacon*, London  2013
- Michael Peppiatt, *Francis Bacon in Your Blood: A Memoir*, London 2015
- Philippe Sollers, *Les passions de Francis Bacon*, Paris 1996
- David Sylvester, *The Brutality of Fact: Interviews with Francis Bacon*, London 2016

# FILMOGRAPHY

- John Maybury, dir., *Love Is the Devil*, 1998
- Collection of videos on YouTube: http://bit.ly/Baconvideo

# ACKNOWLEDGMENTS

My thanks go out to all the people who were close to me during the months of creating this book. Many thanks to Valentina Manchia, Valentina Pederiva, and, especially, Gianluca Carrarese.

Thank you, Silvia Rocchi, for the palette of endpapers.
And thank you Balthasar Pagani, Marco Ficarra, Sandra Sisofo, and Francesco Matteuzzi, for the publication, the graphics, and the editing of this volume.